CREATIVE PAINTING

& beyond

Inspiring tips, techniques, and ideas for creating whimsical art in acrylic, watercolor, gold leaf, and more

Alix Adams, Chelsea Foy & Gabri Joy Kirkendall

Walter Foster

Quarto is the authority on a wide range of topics.
Quarto educates, entertains and enriches the lives of our readers—
enthusiasts and lovers of hands-on living.
www.quartoknows.com

Walter Foster

6 Orchard Road, Suite 100
Lake Forest, CA 92630
quartoknows.com
Visit our blogs @quartoknows.com

This book has been produced to aid the aspiring artist. Reproduction of the work for study
or finished art is permissible. Any art produced or photomechanically reproduced from this
publication for commercial purposes is forbidden without written consent from the publisher,
Walter Foster Publishing.

Printed in China
3 5 7 9 10 8 6 4

Table of CONTENTS

Introduction.....4

How to Use This Book.....5

Introduction

EVERYONE IS AN ARTIST—you don't need any special training, expensive tools, or a fancy studio to make beautiful works of art. All you really need is a little time, a spark of creativity, and to grant yourself the freedom to play. That's what *Creative Painting & Beyond* is all about!

In the pages of this book, you'll find a variety of fun, easy-to-follow painting exercises and step-by-step projects that use a variety of paint types, including watercolor, gouache, craft paint, liquid gilding, and even gold leaf! Each project features simple instruction and beautiful images to inspire. With the guidance of the three talented DIY artists featured in this book, you will learn how to use paint and a few brushes to create unique works of art, stationery, home décor, gifts, and more.

With the painting projects in this book—and helpful artist tips throughout—you'll soon be on your way to painting and creating your own beautiful, creative pieces. So get your brushes ready...this is just the beginning!

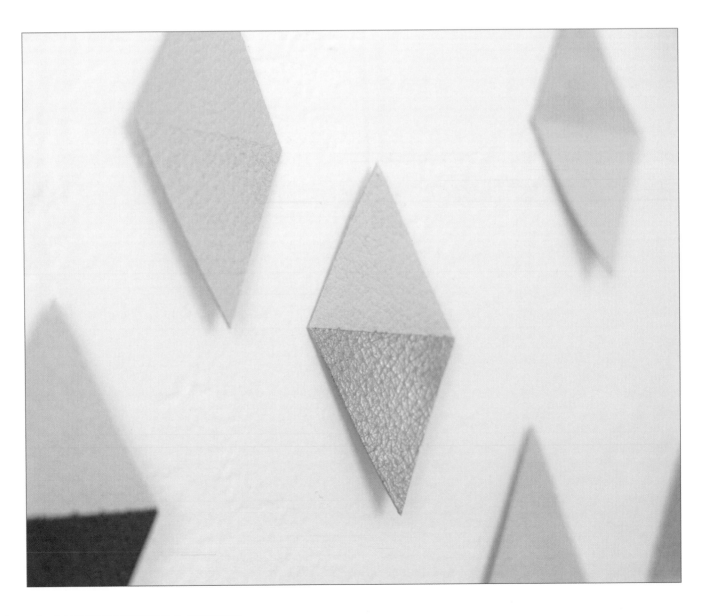

How To Use This Book

THE PROJECTS IN THIS BOOK are designed to inspire you to create unique hand-painted works of art, gifts, home décor, and more! Each project includes a list of the materials needed to complete it. All of the materials for the projects in this book can be found at your local art & craft store or favorite art supplies retailer.

Creative Painting & Beyond is divided into three sections. Each section is packed with fun, unique painting projects from a talented DIY artist! There's no need to work through the projects in the order that they appear—choose the project that catches your attention first, and work your way through the rest as inspiration strikes.

These projects are designed to engage and fuel your innate creative self. Experiment and explore! Allow your imagination to lead the way, guiding you to your own artistic expression. Each project featured in this book is easily customizable, so you can tweak them to match your personal preferences and style!

Ready to start painting? Turn the page to get started!

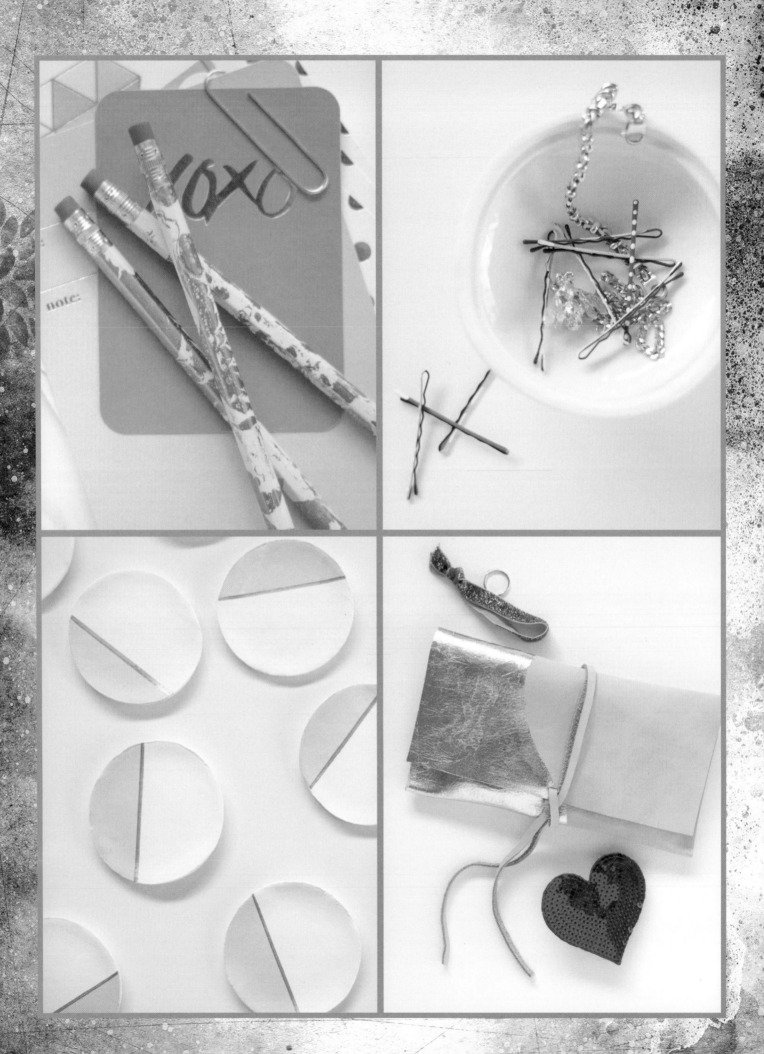

section one

CHELSEA FOY

CHELSEA FOY IS THE MAKER behind *Lovely Indeed*, a DIY and lifestyle blog about all of the lovely things in life. Her work has been featured on Apartment Therapy, Buzzfeed, HGTV, Better Homes and Gardens, and more. She recently co-authored *Make Your Day*, a digital crafting book. Chelsea resides in California with her adorable husband, where they spend their time adventuring, exploring, creating, and being generally smitten with their tiny son, Henry. Visit www.lovelyindeed.com to learn more.

Gold Leaf
LETTERED ART

IF YOU NEED AN EXTRA dose of inspiration around the house, this project is just the ticket! You can personalize it with your favorite saying or choose a phrase that's perfect for a friend to make a gift that's totally one of a kind. I just love the way gold leaf looks when it's applied over lettering—totally fresh and fun!

MATERIALS
- Card stock
- Gold leaf
- Gold leaf adhesive
- Small, fine-point paintbrushes
- Gold leaf duster brush
- Computer & printer (optional)
- Pencil (optional)

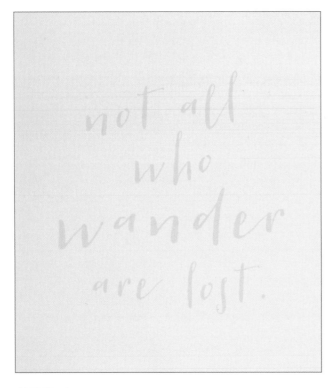

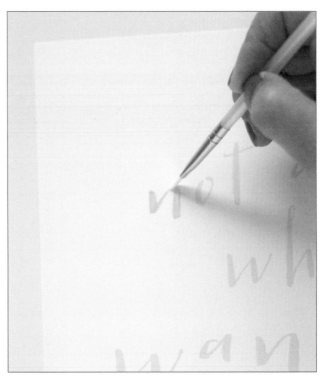

STEP 1
Choose a phrase to write on the card stock, and write the words using very light pencil strokes, or use a computer to print the phrase on card stock in your favorite font. If you choose the printed option, print in a very light gray color, so that you can just see the words.

STEP 2
Dip a small, fine-point brush into the gold leaf adhesive. Carefully trace over the first word with the adhesive. Create just a thin layer—don't allow the adhesive to pool.

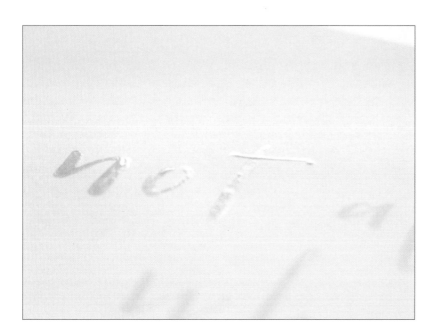

STEP 3

Allow the adhesive to dry slightly until tacky—just a minute or two.

STEP 4

Take a sheet of gold leaf, and place it gold-side down over the adhesive. Use your fingers or a clean, dry paintbrush to pat it down and ensure it adheres well.

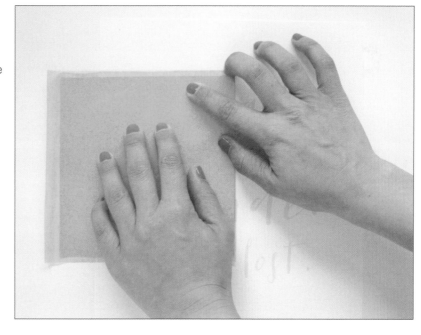

STEP 5

Peel the gold leaf sheet away; be careful not to pull too quickly or forcefully. Sometimes it helps to leave a finger over the portion with the adhesive to ensure it sticks.

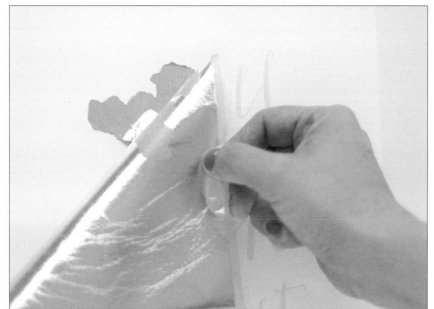

STEP 6

Using the duster brush, begin to dust away the leaf that isn't adhered to the word. Use small, circular motions to gently scrub away the excess leaf. Approach it from various angles to get any little bits that may want to cling to the paper.

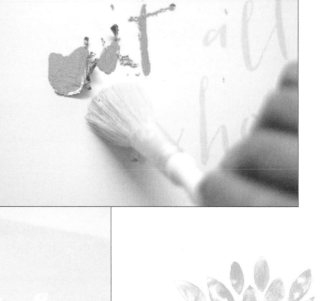

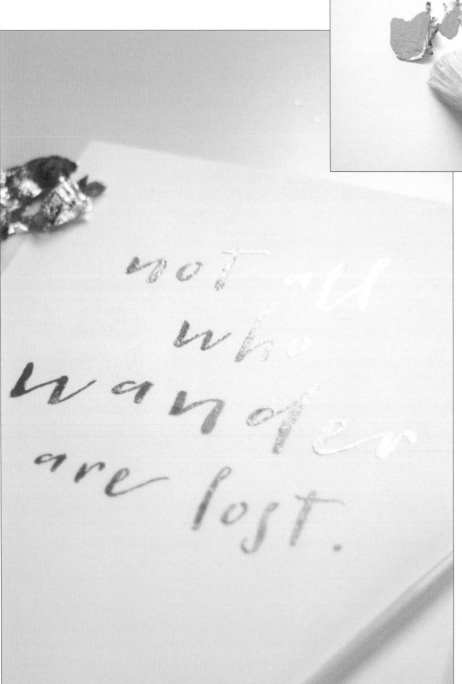

STEP 7

Repeat the process with the rest of the words on the card stock.

It may be Tempting to work on a few words at a time, but you will achieve the best results working one by one!

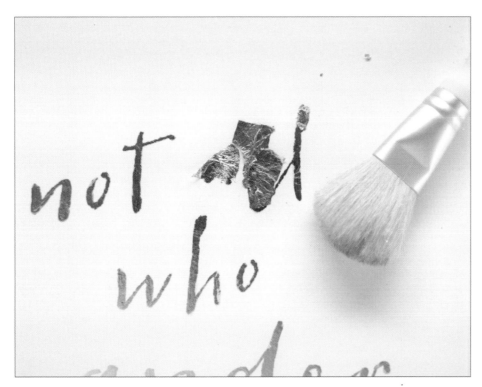

STEP 8

Once your entire phrase is covered with gold leaf, spot check for any places that may have been missed or need retouching. Simply repeat the process on those small, individual areas.

STEP 9

Hang your artwork and be inspired! This project is perfect for making greeting cards and place cards—or think big, and make some golden signage for a wedding or shower!

Painted-Leather
GEOMETRIC WALL HANGING

ADD A MODERN "POP" to your décor with this sleek, fun geometric wall hanging! I'm all about geometric shapes—the clean lines are a perfect backdrop for experimenting with fresh color palettes and different arrangements. Choose your favorite shade of leather and a pretty palette of paints to customize one of these hangings for yourself!

MATERIALS

- Leather
- Cutting mat
- Rotary cutter
- Ruler
- Craft paint (various shades)
- Paintbrushes
- Painter's tape
- Needle
- Thread
- Wooden dowel
- Baker's twine

STEP 1
Place the leather on a cutting mat. Use the rotary cutter alongside a ruler to cut out diamonds. Make them any size you like! Mine are 4 inches high by 4 inches wide.

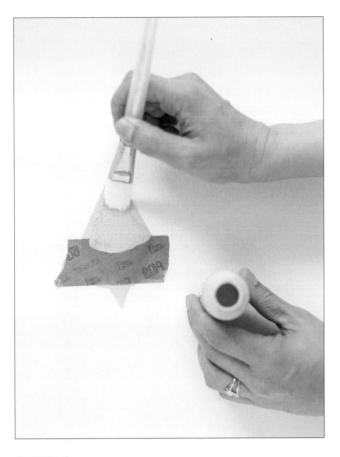

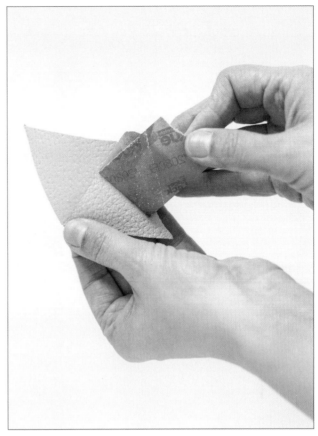

STEP 2

Place a piece of painter's tape across the center of each diamond, from tip to tip. Then spread a layer of craft paint over the area without tape. Use enough paint to cover the surface of the leather, but not so much that it pools or overly saturates.

STEP 3

Remove the painter's tape while the paint is still slightly wet. Paint each piece of leather in a similar fashion, and allow all the pieces to dry thoroughly.

Begin your brushstrokes

over the painter's tape and pull the brush away from it to achieve a cleaner line when you take the tape off. This helps prevent paint from seeping underneath the tape.

STEP 4

Thread your needle, and insert it through the top of a diamond, almost at the upper tip. Leave the thread a bit long so that you can play with the length once you add the diamonds to the dowel.

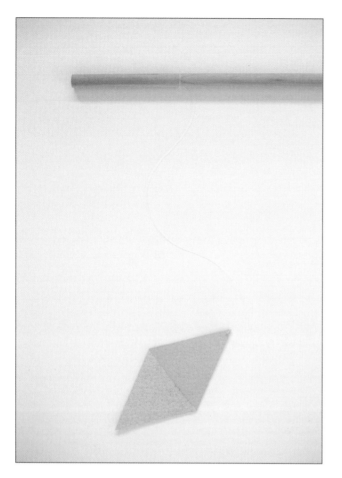

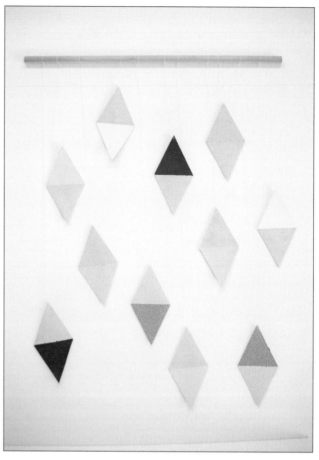

STEP 5

Remove the needle, and knot the thread behind the diamond to secure it. On the other end, wrap the thread and tie it around the wooden dowel.

STEP 6

Repeat steps 4 and 5 with each diamond. Hang them each at a slightly different length from the dowel to create visual interest.

STEP 7

Cut a length of baker's twine, and tie each end around the ends of the dowel to create a hanger. Hang up your new geometric artwork and enjoy!

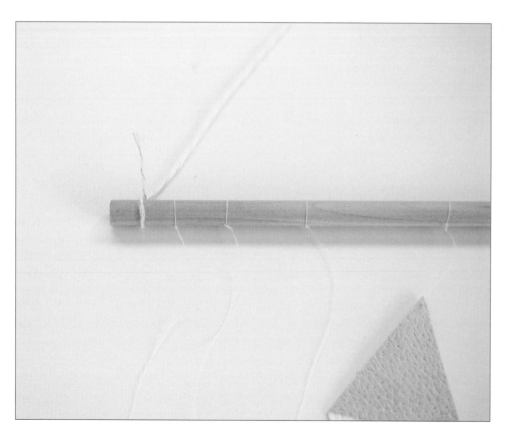

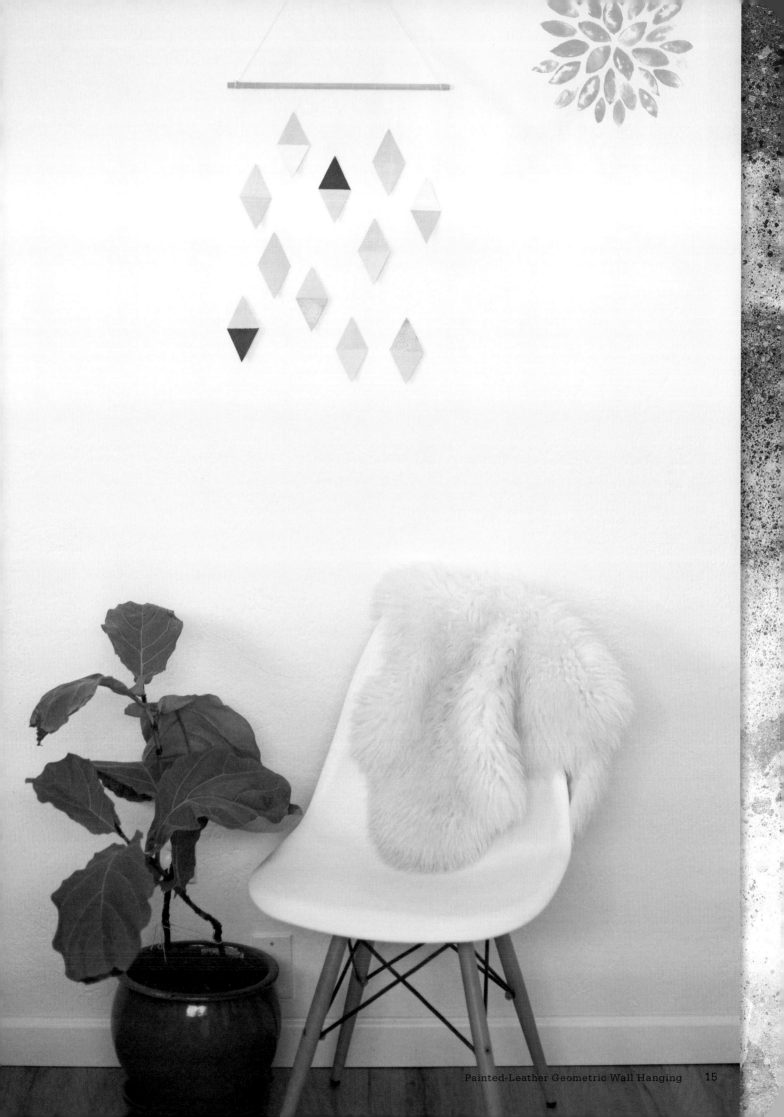

Painted-Pattern SWEATER

I SECRETLY LOVE IT WHEN SOMEONE ASKS where I got a piece of clothing and I can say that I made it—or at least part of it! This painted-pattern sweater project is one of my favorites because you can take a simple piece of clothing and customize it any way you like. Play with the shapes, colors, and arrangement of the pattern; there's no end to the possibilities! I guarantee that when you wear it, folks will ask where you found it!

MATERIALS

- Plain sweater or shirt
- Craft paint
- Paintbrush
- Freezer paper
- Scissors
- Craft knife
- Pencil
- Iron
- Shape punch or cutting machine (optional)

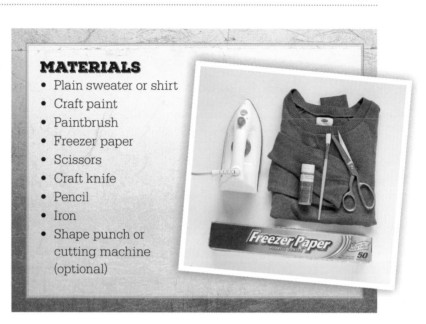

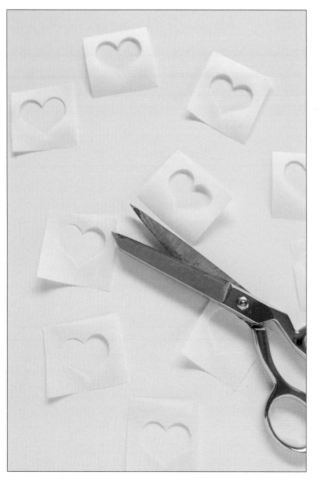

STEP 1

Choose a shape for your pattern. Anything is fair game! Just be sure to select a shape that will read well once it's on the fabric—it's best to avoid anything too detailed. Cut the shape out of small squares of freezer paper. If you are cutting by hand, use a pencil to draw the shape, and then cut it out with scissors or a craft knife. A simpler solution is to use a craft punch to punch out the shape multiple times. You'll need about 25 to 30 squares of your shape, depending on how you arrange the pattern.

If you have a cutting machine, such as a Cricut® Explore™, this is a great project to put it to work! Use the Cricut to cut out all the shapes in just a few minutes.

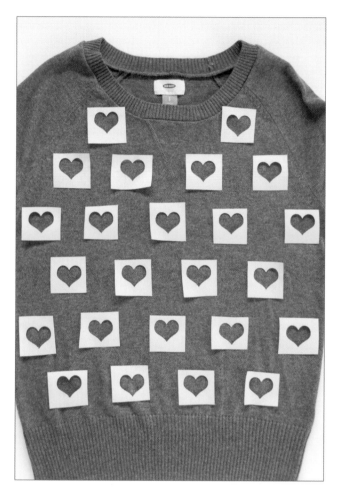

STEP 2

Arrange the shapes on the sweater. Play with the positioning until you are happy with the pattern. Be sure to place the freezer paper shiny-side down.

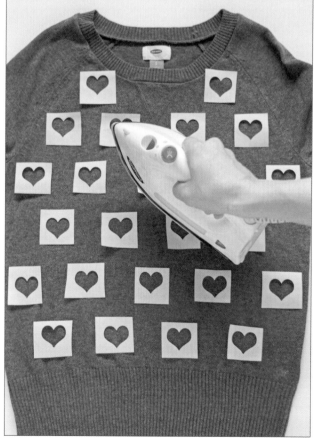

STEP 3

Set your iron to high heat. Gently iron over each piece of freezer paper for a few seconds—it won't take long! The iron will temporarily adhere the paper to the fabric.

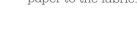

To get the cleanest edges,
begin at the outer edge of the freezer paper and angle your brushstrokes inward toward the center of your shape. This will prevent paint from seeping underneath the edge of the paper.

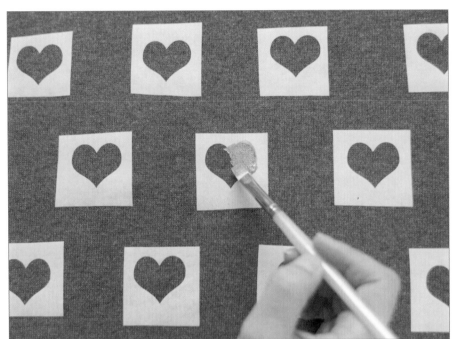

STEP 4

Load the paintbrush with your favorite color, and begin painting in the freezer-paper stencils. Be careful to cover the fabric completely and evenly. If you're working with a thin fabric, place a piece of cardboard between the layers to prevent the paint from seeping through.

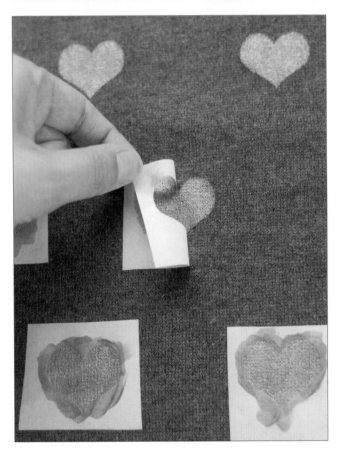

STEP 5

Once all the shapes are painted, remove the freezer paper stencils one by one. It helps to do this while the paint is still a little wet. Be careful not to touch or smear your shapes!

STEP 6 ➤

Allow the pattern to dry thoroughly. Wear your new top out on your next adventure, and be ready for everyone to ask where you got that adorable sweater!

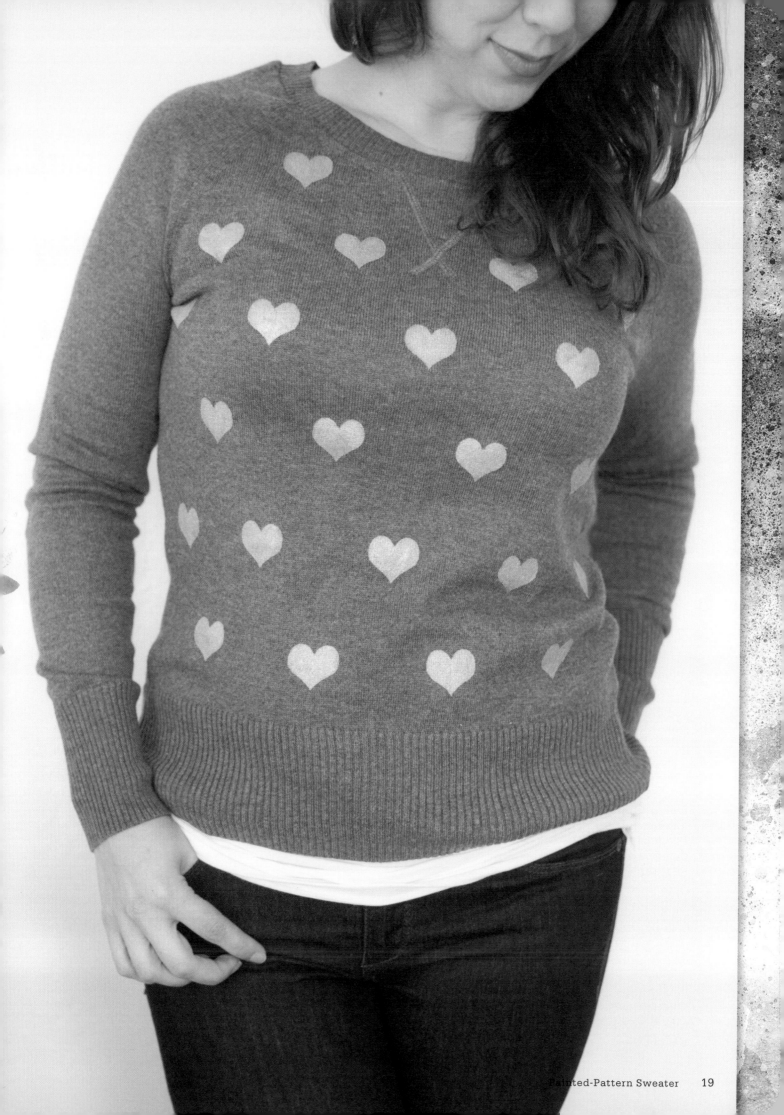

Screen-Printed
POP ART

THIS SCREEN-PRINTED POP ART PROJECT is such a cool and unexpected way to add a little art to your walls! Screen printing may seem like a difficult or advanced skill, but it's actually pretty simple. Once you give it a try, you'll be screen printing everything you own!

MATERIALS

- Blank stretched canvas
- Craft paint
- Liquid gilding
- Mod Podge®
- Small paintbrushes
- 2 small foam paintbrushes

- Computer and printer
- Permanent marker
- Scissors
- Embroidery hoop
- Sheer fabric (organza works well)
- Washi tape (optional)

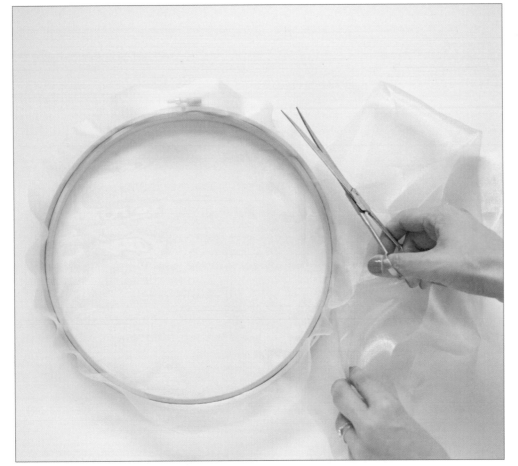

STEP 1
Stretch the sheer fabric across the embroidery hoop and secure it with the inner hoop, pulling taut on all sides to ensure there are no wrinkles. Trim around the edges of the fabric to clear away the excess.

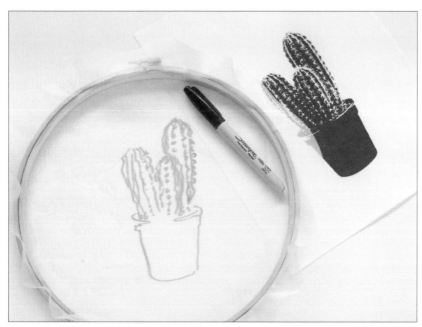

STEP 2

Find an image to screen print. Black-and-white, high-contrast images that consist of simple shapes work best. Print the image on white paper. Then place the fabric hoop over the printed image. Trace the image lightly onto the fabric with a permanent marker. Be sure to trace along all edges—anywhere there is white space should be traced!

STEP 3

Using a variety of small paintbrushes, apply Mod Podge over all the *negative space*—anywhere there is white on the printed image. Let dry, and then apply a second coat of Mod Podge over the first layer.

STEP 4

If you'd like to map out where the images will be screen printed, create a grid on the canvas using washi tape.

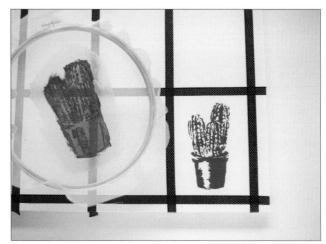

STEP 5

Carefully screen on the images. Set the hoop over the spot where you want the image to appear. Load a small foam brush with a good amount of craft paint. Being careful not to let the hoop move, press paint over the image firmly. Add paint until the entire image is covered. Gently pull away the screen, and you should have a screen-printed version of your image.

You may find

that it works better to apply the paint in strokes rather than pressing it in. Experiment first on a piece of paper to see which technique works best for you.

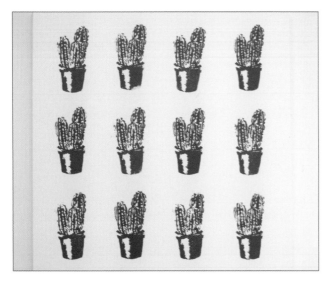
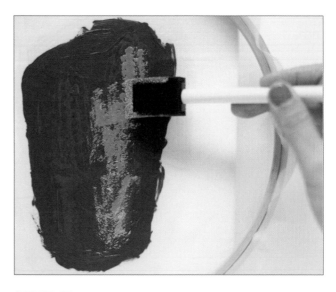

STEP 6

Repeat the process until you have filled the canvas with the image. Allow the canvas to dry completely.

STEP 7

Choose a few spots to add a little gold. Once the canvas is dry, set the screen down again on one of the images and brush on a bit of liquid gilding with a new foam brush. Don't cover the entire screen; apply only to about half of the image. Pull the screen carefully away.

STEP 8

Allow the gilding to dry completely. Then put up your new pop art and admire!

Enamel-Painted
BOBBY PINS

I LOVE TAKING SOMETHING SIMPLE and making it into something special, especially when it just takes a few easy steps! I'm constantly using bobby pins and have them stashed everywhere. In this painting project I'll show you how to use enamel paint to turn plain old bobby pins into an accessory you'll want to show off.

MATERIALS
- Plain bobby pins
- Enamel paint
- Small paintbrushes
- Toothpicks
- Sheet of paper

STEP 1

Line up the bobby pins by slipping them onto a piece of paper. You'll paint the flat side of the bobby pins, so arrange them with the crimped side down. Leave enough space between each pin for your paintbrush to maneuver comfortably. Dip a small paintbrush into the enamel paint. I like to load the paintbrush with a good amount of paint and spread it onto the bobby pin in a thick layer. Brush on the paint, creating a smooth finish. Reload your brush as needed to keep the thickness of the paint consistent.

STEP 2

Once all of the bobby pins have a base coat of color, allow the paint to dry according to the directions on the paint packaging. For enamel paint, I like to let a coat dry overnight to cure. If you'd like a more opaque or more brilliant color, add another coat of paint to your pins once the first coat is dry.

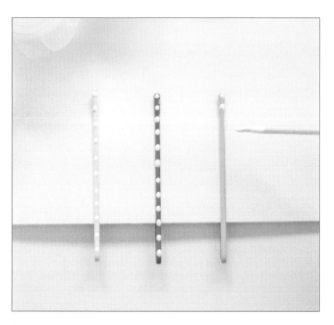

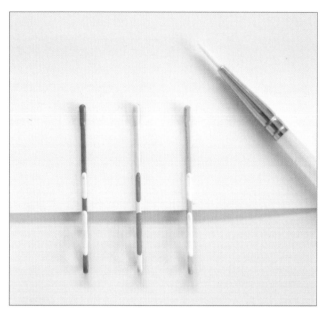

STEP 3

Add some fun details! Grab a toothpick—they're perfect for making teeny-tiny designs. To create polka dots, dip the toothpick in paint and gently touch it to the bobby pin. Reload the toothpick with paint for each dot.

STEP 4

For a color-block design, use a paintbrush to add stripes of contrasting color to the painted pins. Alternatively, you can paint all of the tips a single color. Be creative and come up with some new patterns or details!

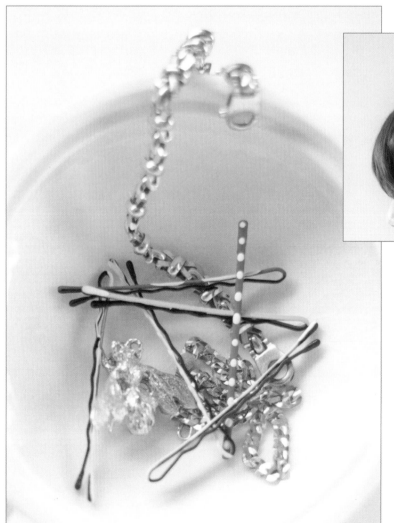

STEP 5

Allow the enamel paint to cure for at least 24 hours or according to the directions on your packaging. Then dress up your 'do with the fancy bobby pins, and take them out for a spin!

Painted
MUG SET

I LOVE A GOOD PATTERN, DON'T YOU? I particularly love a hand-drawn pattern; there's something very cool about the organic feel of shapes that are slightly imperfect because they've been created by hand. These painted coffee mugs couldn't be any simpler, but the hand-drawn pattern makes them look like something you'd find in a cool indie boutique. Try out the circle pattern, or create your own—you can't go wrong!

MATERIALS
- Glass paint
- Plain coffee mugs
- Oven
- Paper towels

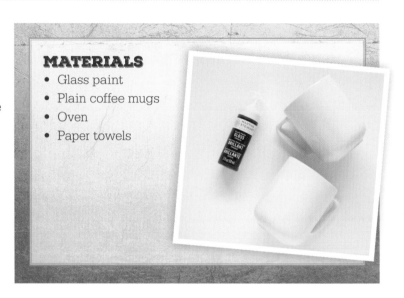

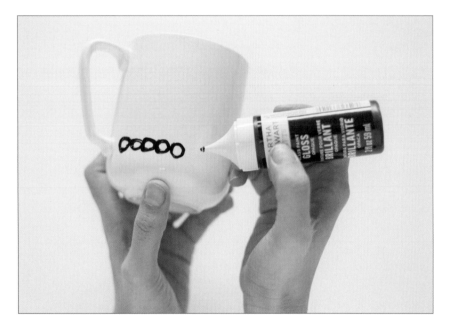

STEP 1
Wash and dry the mugs thoroughly. It's important that they're clean and dry, with no debris on the surface, so that the paint will stick well. Start painting your pattern! Gently squeeze the bottle until the paint starts flowing, and move the paint around with the bottle tip. It's easiest to start near the handle of the mug so that you have a point of reference to keep the pattern straight. Be careful not to squeeze out too much paint!

→ *Before you start painting,* ←
flip the bottle of glass paint upside down and pat it on
the heel of your hand to work all of the paint toward the tip.
This will help guard against air bubbles that might work their
way out and make paint splatters on your mug.

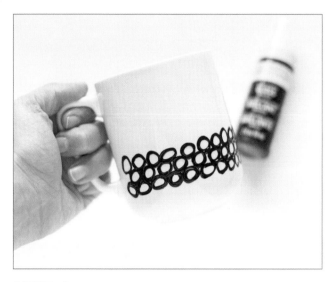

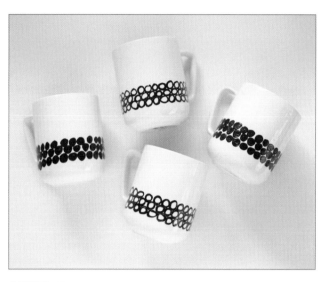

STEP 2

Continue the pattern until you're satisfied with the design. Since it's freehand, there's no right or wrong way to go. I liked the look of three rows of circles, so I stopped there. But be creative—cover the whole mug if you like!

STEP 3

Add painted patterns to the rest of the mug set. Use varying patterns, or keep the same design on each mug. You could try varying colors as well!

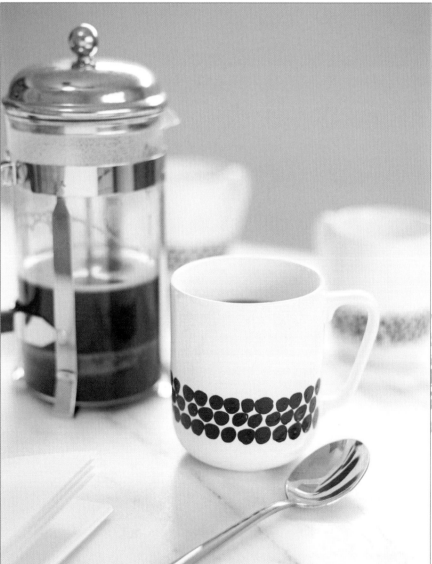

STEP 4

Allow the paint to dry and cure thoroughly, according to the directions on your paint packaging (most will require baking in the oven). Now you're ready to fill the mugs with something warm and delicious and sip away!

Leather &
GOLD LEAF POUCH

A GIRL NEEDS PLENTY OF PLACES to keep her trinkets, am I right? I needed a little pouch to store a few girly odds and ends, so I dreamed up this leather-and-gold-leaf beauty. And part of what's so beautiful about it is that you don't need to sew a single stitch to put it together—just a few simple steps, a tiny golden touch, and you'll have a perfect little pouch to store all of your trinkets too!

MATERIALS

- Leather
- Gold leaf sheets
- Gold leaf adhesive
- Paintbrush
- Gold leaf duster brush
- Scissors and/or rotary cutter
- Cutting mat
- Strong glue
- Clothespins (optional)
- Craft knife (optional)

STEP 1

Use scissors or a rotary cutter with a cutting mat to cut a piece of leather into a 7" x 11" rectangle.

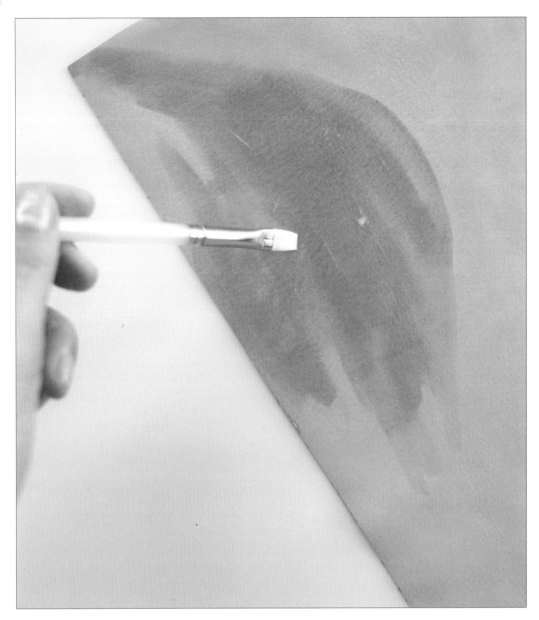

STEP 2

On the outer side of the leather, paint a layer of gold leaf adhesive. I decided to create a stripe of gold that will match up in the front when the pouch is closed, but use your imagination and create any shape you like! Use enough adhesive to lightly saturate the leather, but be careful not to leave any puddles.

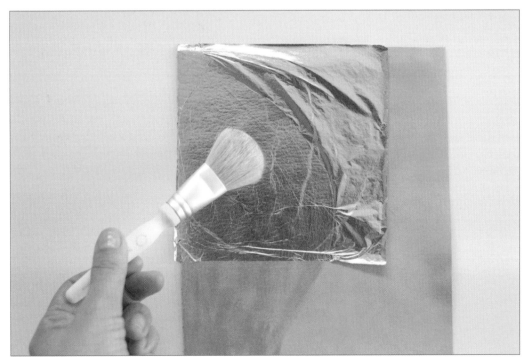

STEP 3

Allow the adhesive to dry for a few minutes until it becomes tacky. Lay sheets of gold leaf over the tacky adhesive, and then pat them down gently with the duster brush to ensure the leaf sticks. Cover all the areas of adhesive.

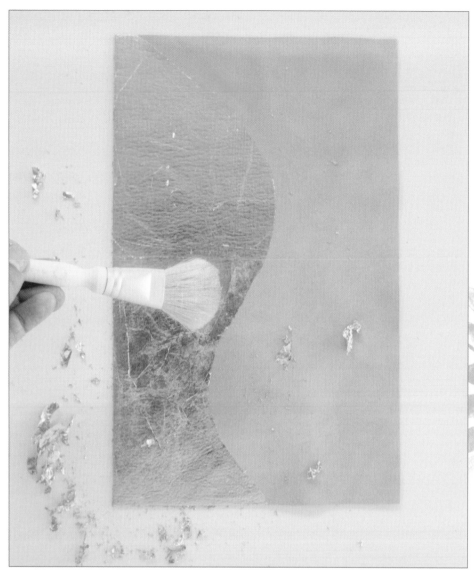

STEP 4

Gently remove the large portions of gold leaf that are not adhered to the leather. (You can set these aside for another project!) Then use the duster brush to gently buff around the edges of the gold leaf in small circles to clear away all the excess gold. Keep buffing until the leaf is smooth.

STEP 5

Place the leather outer-side down. Apply a line of glue along the outer edges in the center third of the leather.

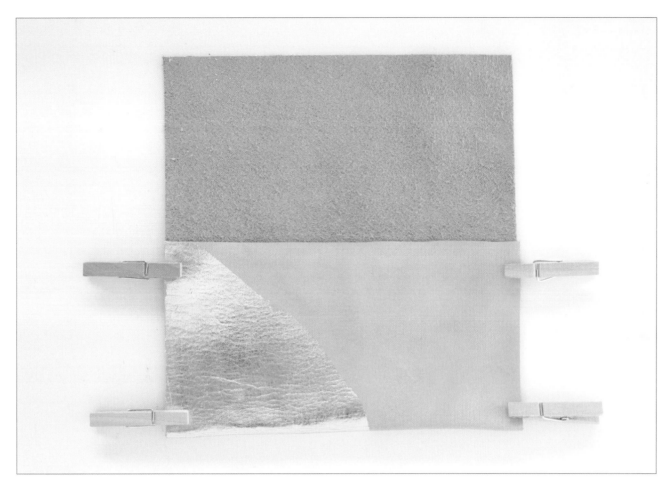

STEP 6

Fold up the bottom third of the leather, and adhere it to the lines of glue. Be sure to wipe away any excess glue that seeps out the sides. If you like, you can secure the leather together with clothespins while it dries. Just be sure to remove them before they leave an imprint in the leather.

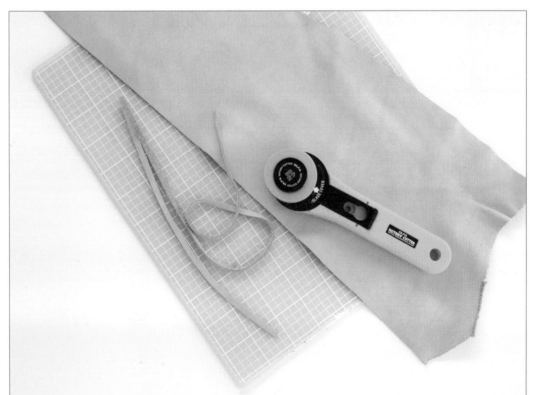

STEP 7

Cut another strip of leather, about 28" x ¼".

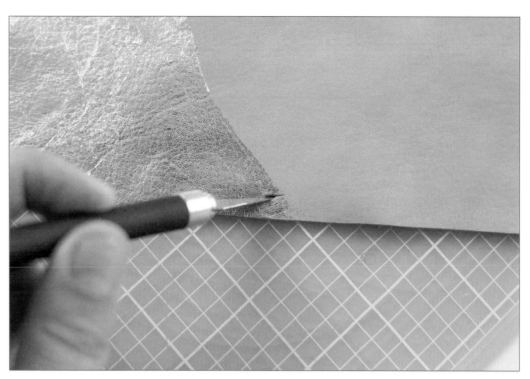

STEP 8

Cut a ¼" slit in the bottom center of the front flap of the pouch.

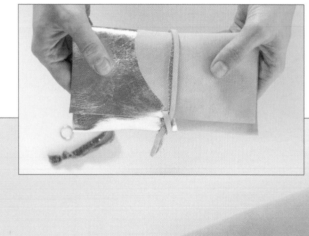

STEP 9

Thread the long strip of leather through the slit. To close your pouch, wrap the strip around the pouch and loop it around itself.

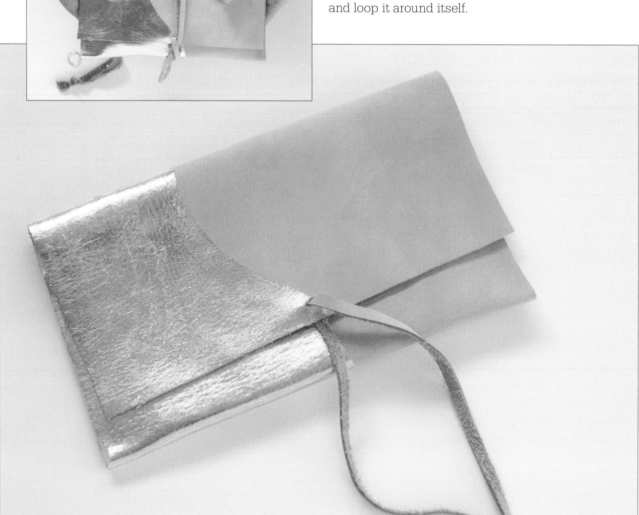

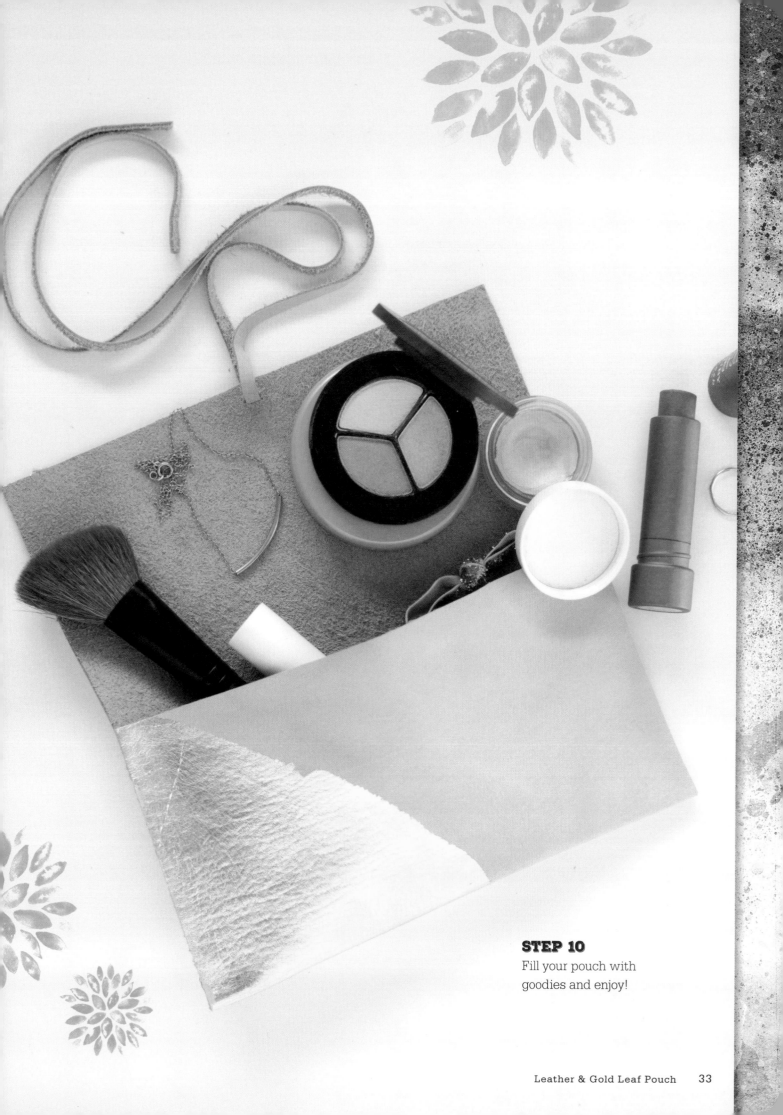

STEP 10

Fill your pouch with goodies and enjoy!

Gold Leaf CLOCK

ARE YOU ALWAYS RACING THE CLOCK? How about making a timepiece that's at least pretty to look at? This gold leaf clock is one of my favorite projects—it's simple to put together and looks pretty fancy up on the shelf. Make one for yourself, and keep time in style!

MATERIALS

- Black foam core board
- Raised number stickers
- Cutting mat
- Craft knife
- Gold leaf
- Gold leaf adhesive
- Small paintbrush
- Gold leaf duster brush
- Clockwork kit
- Salad plate

STEP 1

Start by cutting out the circle for the clock base. Place your foam core board on the cutting mat, and place the salad plate upside down on the foam core board. Trace around the plate with a craft knife, cutting out a circle.

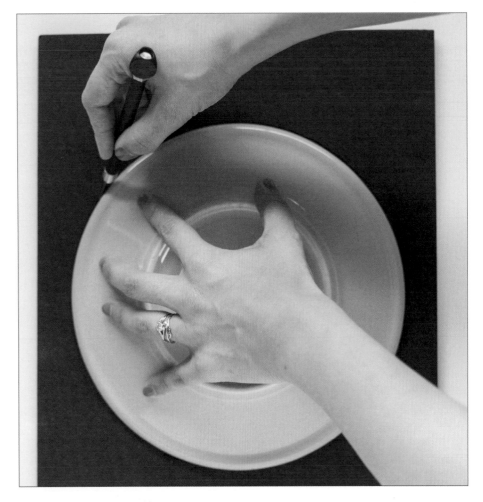

You may need to make a few passes with the craft knife to get a good, clean cut that goes all the way through the board.

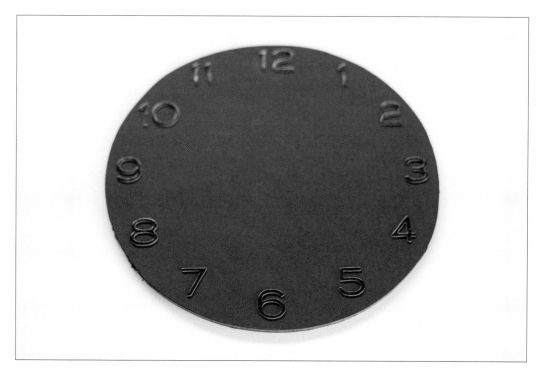

STEP 2

Place the number stickers around the clock. Be sure to use stickers that are raised and have a bit of depth to them—it will be much easier to apply gold leaf to the surface.

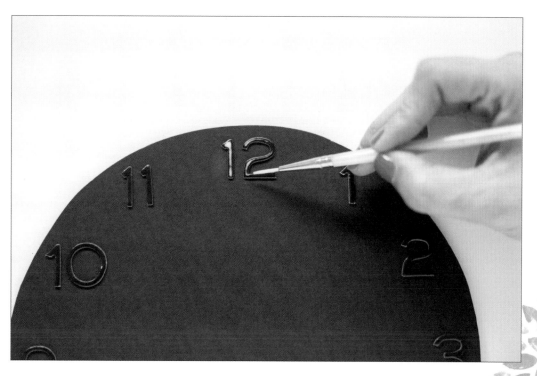

STEP 3

Brush a thin coat of gold leaf adhesive onto each number. Try not to allow too much pooling. Let the adhesive dry for a minute or two, until it's tacky to the touch.

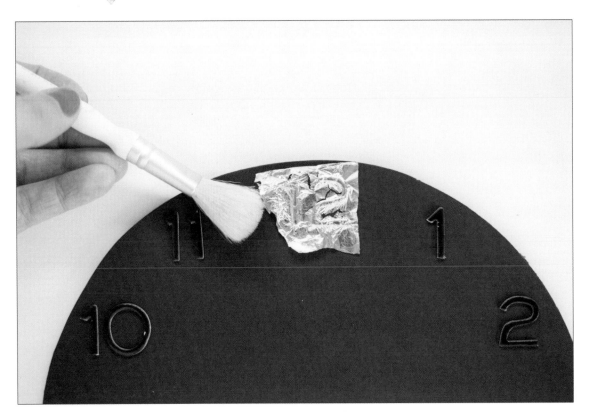

STEP 4

Apply pieces of gold leaf to the numbers, and pat the gold leaf down gently with a brush.

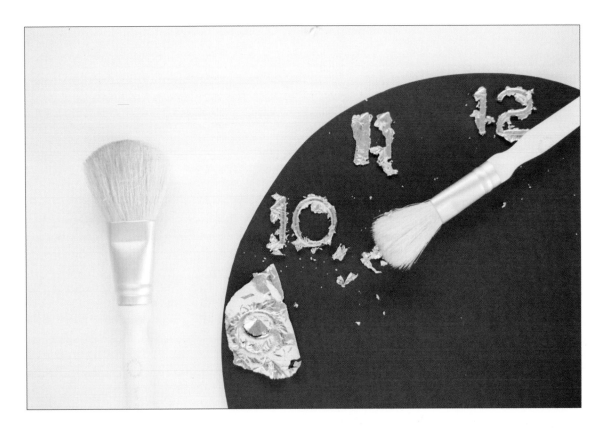

STEP 5

Once all of the gold leaf is adhered, use the duster brush to gently dust away the excess.
You may need to use a smaller brush to get into the crevices of the numbers.

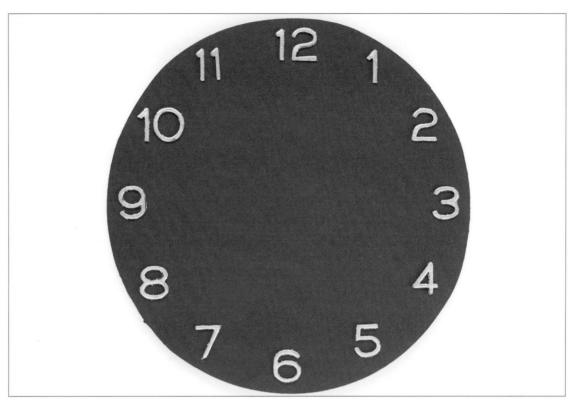

STEP 6
Continue to work all around the clock, applying gold leaf to each number.

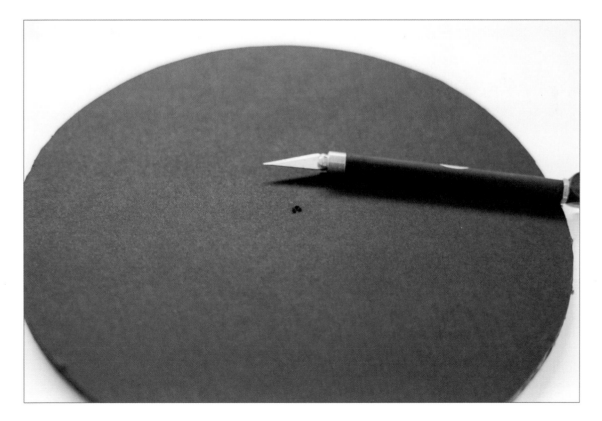

STEP 7
When you are done with the numbers, flip the clock over, and bore a hole in the center with a craft knife. Keep making the hole larger until the clockwork will fit through the hole, from back to front.

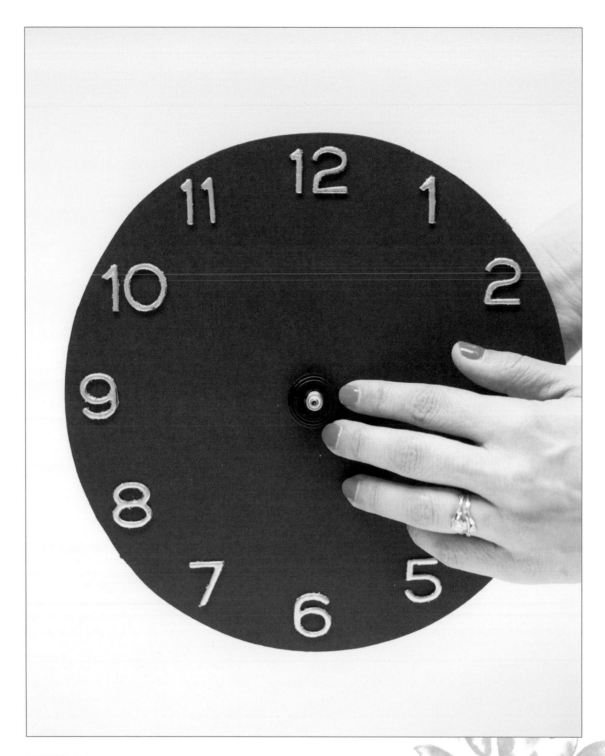

STEP 8

Insert the clockwork, and assemble it according to the directions on the packaging.

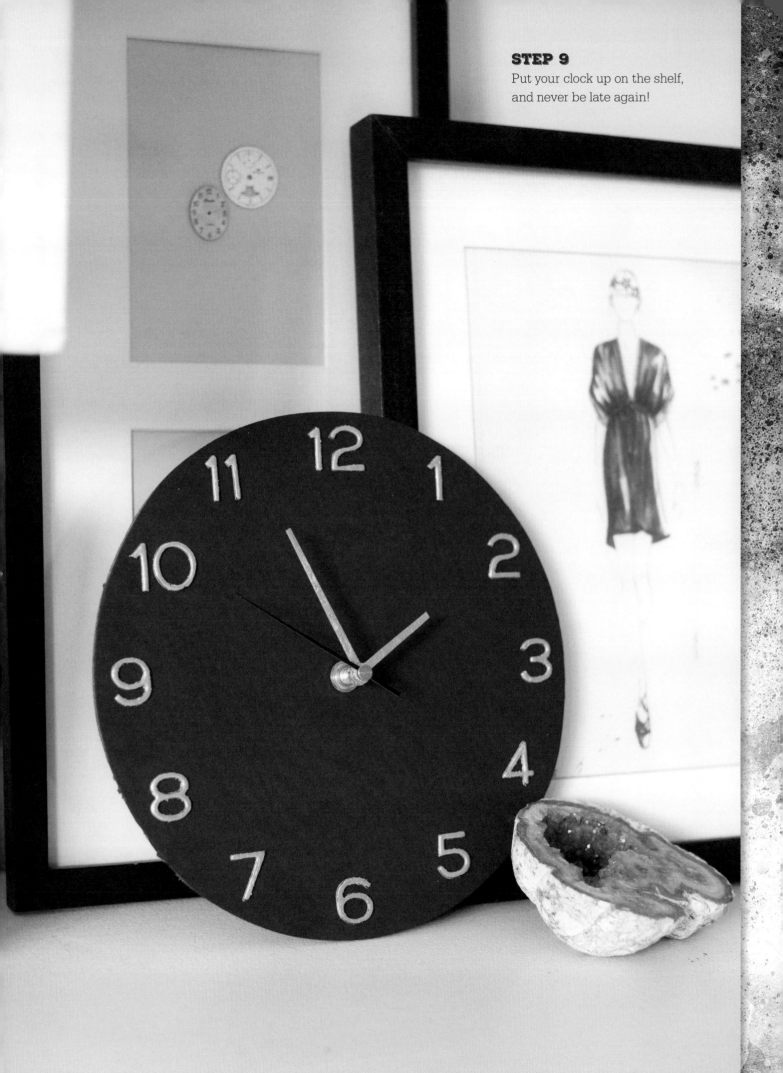

STEP 9
Put your clock up on the shelf, and never be late again!

Gold-Marbled PENCILS

WHY WRITE WITH A PLAIN OLD NO. 2 PENCIL when you can fancy it up a bit? This project takes something very simple—a pencil—and makes it into something pretty special! A pencil is the last place you'd expect to find gold marbling, but it makes perfect sense to me. Your desk is going to be so happy!

MATERIALS
- Plain wooden pencils
- Craft paint
- Liquid gilding
- Paintbrush
- Painter's tape
- Clothespins
- Disposable plastic container
- Toothpicks
- Paper towels

STEP 1
Use a small piece of painter's tape to tape off the metal eraser portion at the top of each pencil.

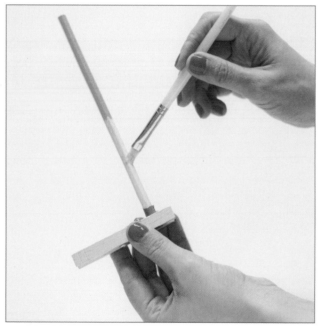

STEP 2
Clamp each pencil in a clothespin. The taped-off portion should fit snugly in the rounded part of the clothespin. Apply a coat of craft paint to the wooden portion of the pencils. You can hold onto the clothespin as you paint to keep your fingers clean.

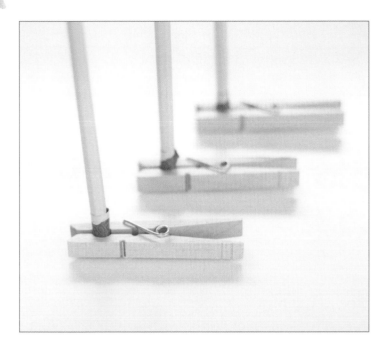

STEP 3

Set the pencils up to dry, using the clothespins as stands. If necessary, apply a second coat of paint once dry. Remove the painter's tape from the tops of the pencils once all the layers of paint are dry.

→ *Liquid gilding will* ←

leave some residue on the bowl. It's best to use a disposable plastic tub, which you can either dispose of when you are finished or keep for future marbling projects.

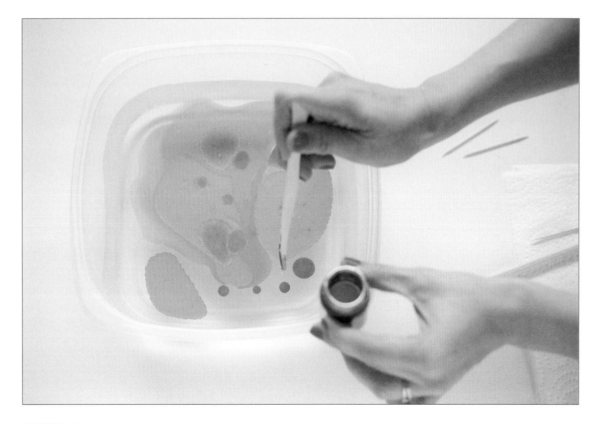

STEP 4

Prepare the gold marble bath. Fill the plastic tub halfway with water. Gently add drops of liquid gilding to the water. Some will spread, and some will remain intact; this is fine! Continue adding drops until the surface is somewhat covered.

If you find the drops of gilding are sinking to the bottom, try dropping them more gently from just above the water's surface. Additionally, check the temperature of your water—room temperature is ideal.

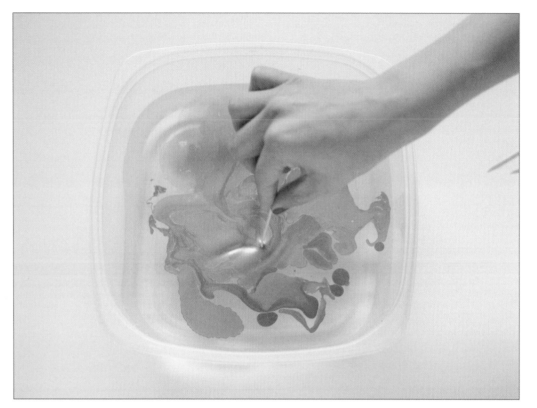

STEP 5

You need to work somewhat quickly with gilding, as it will dry and harden if you wait too long. Once you finish dropping the gold, use a toothpick to swirl the surface of the water and create a marbled pattern.

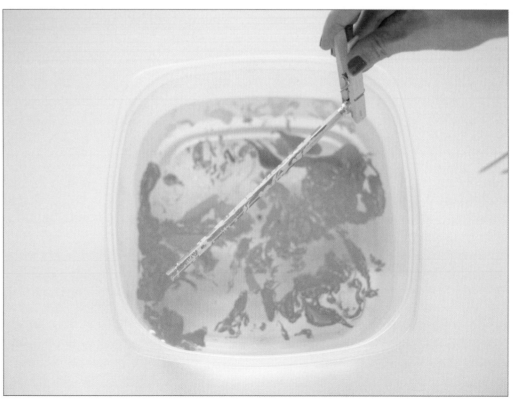

STEP 6

With the clothespin, gently dunk the painted portion of a pencil under the surface of the water. It will pick up the gold lying on the top. Pull the pencil out of the water, gently shake off any excess drops, and prop the pencil up on the clothespin again to dry. Repeat with all the pencils.

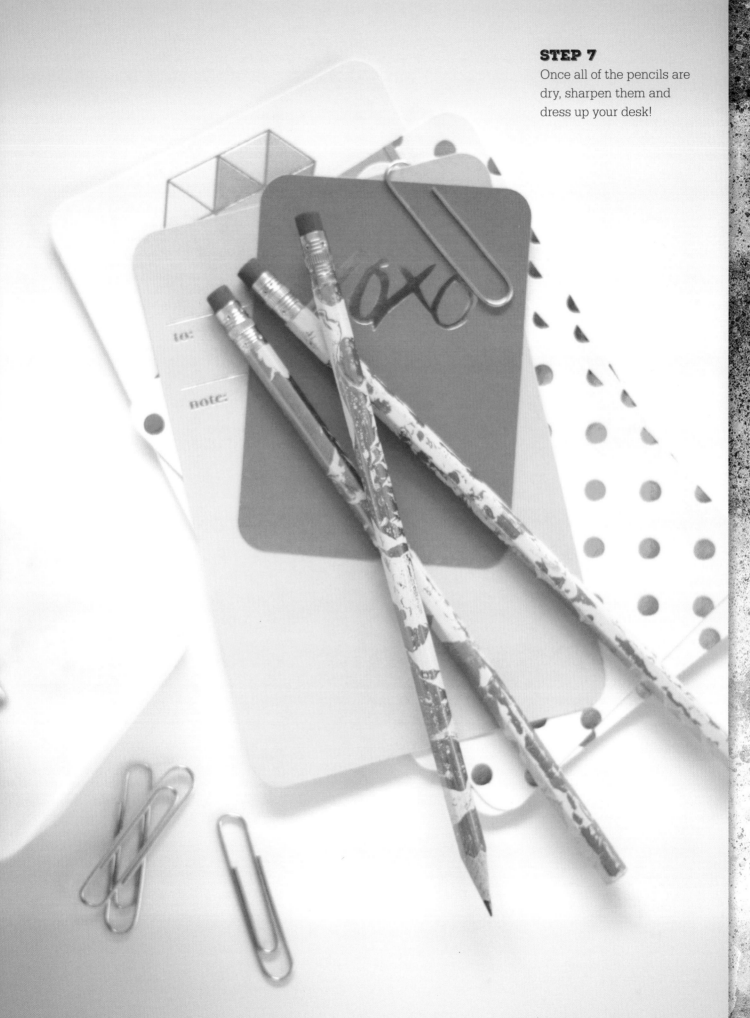

STEP 7

Once all of the pencils are dry, sharpen them and dress up your desk!

Gilded Clay
TRINKET DISHES

AIR-DRY CLAY IS ONE OF MY FAVORITE SUPPLIES to work with and paint—it's a perfect clean palette, and you can create items that are both pretty and functional! That's what I love most about these little trinket dishes. The look of the clay is elevated with a pop of color and a stripe of gold, and it's the perfect spot to keep a few trinkets! Make a few for yourself, or give them as pretty handmade gifts.

MATERIALS

- Air-dry clay
- Craft paint
- Liquid gilding
- Paintbrushes
- Water glass (with smooth sides and rim)
- Washi tape

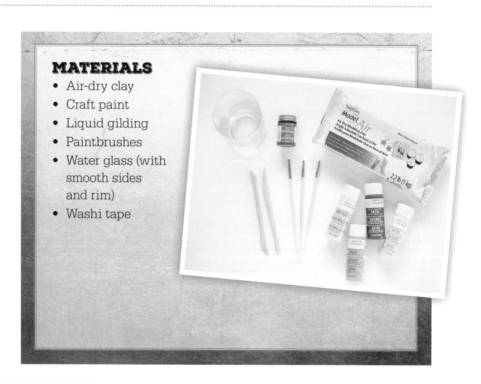

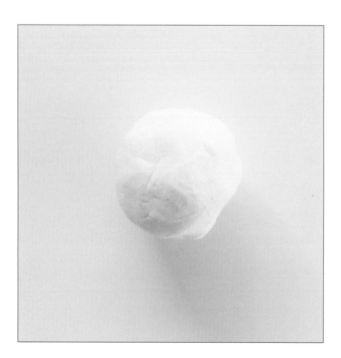

STEP 1

Cut off a hunk of air-dry clay, and knead it until soft (it should be pretty soft to begin with). Roll it into a small ball.

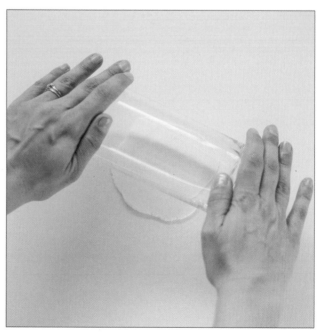

STEP 2

Make sure the outside of your water glass is clean and dry. Use the glass like a rolling pin to roll the clay flat until it's approximately ¼" thick.

STEP 3

Flip the glass upside down, and use the rim like a cookie cutter to cut out a circle of clay. Pick up the clay circle, and smooth any rough edges with your finger.

STEP 4

Curl up the edges of the circle to create a little dish. Be sure the edges are curled up evenly around the entire circle. Set the dish aside to dry according to the directions on your clay packaging. I like to let it dry for an extra day or so to be sure it's really cured and solid.

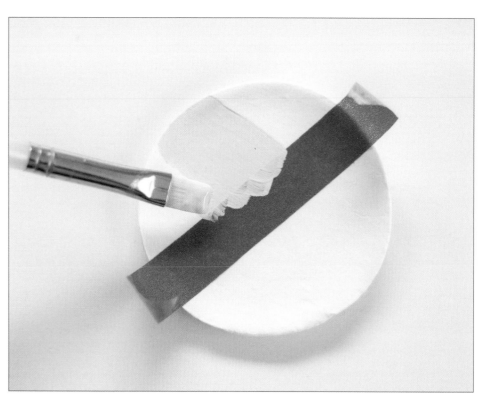

STEP 5

Once the clay is dry, place a strip of washi tape on a diagonal across a portion of the dish. Choose a craft paint, and paint on one side of the washi tape. Be careful not to drip paint over the edges! Pull the washi tape off while the paint is still damp.

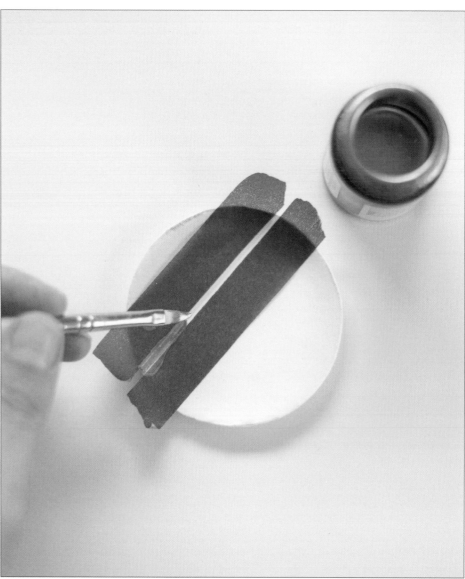

STEP 6

Allow the craft paint to dry fully. Once dry, put two strips of washi tape on either side of the edge of craft paint. Then fill in the space between the tape with liquid gilding. A thin layer should do it! Too much, and you may leak paint beneath the tape.

STEP 7

Pull off the washi tape while the paint is still wet. Allow the dish to dry completely, and then fill it with your favorite trinkets!

Gold Painterly
POLKA-DOT UMBRELLA

THIS LITTLE PROJECT is beyond simple, but it's sure to put a smile on your face on a rainy day! The golden polka dots are such a fun touch to add to your umbrella, you'll be hoping to wake up to cloudy skies.

MATERIALS
- Clear umbrella
- Liquid gilding
- Paintbrush

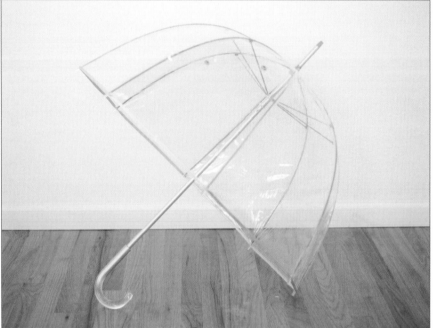

STEP 1
Find a good clear umbrella. Often the quality can be a bit questionable, so look for one that is sturdy and well made. Open the umbrella, and wipe down the inside to ensure the surface is clean and dry.

STEP 2
Load your paintbrush with liquid gilding and start painting large freehand polka dots on the inside of the umbrella.

It's helpful to paint one section of the umbrella at a time and roughly the same number of polka dots in each section. This will ensure equal coverage as you make your way around the umbrella.

STEP 3

Once the umbrella is completely covered with polka dots, start with the first section and paint another coat of liquid gilding on each polka dot.

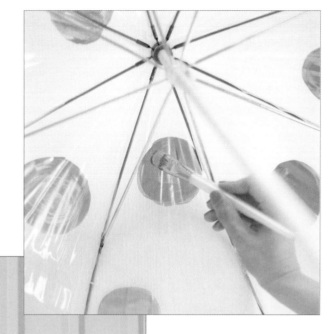

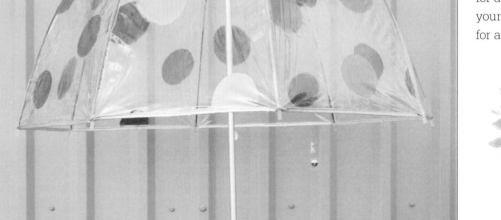

STEP 4

Leave the umbrella open in a well-ventilated area to dry. Then wait for a rainy day, and take your new umbrella out for a spin!

Gilded Leather
MONOGRAM KEY FOB

IF THE KEYS ON YOUR KEY RING are a little lonely, keep them company with a custom gilded monogram! The combination of leather and gold gives this project a polished look that's easy to put together. If monograms aren't your thing, you can paint any other symbols that you like!

MATERIALS
- Leather scraps
- Cutting mat
- Rotary cutter
- Scissors
- Craft knife
- Ruler
- Liquid gilding
- Small paintbrush
- Contact paper or self-adhesive vinyl
- Key rings
- Needle
- Gold thread

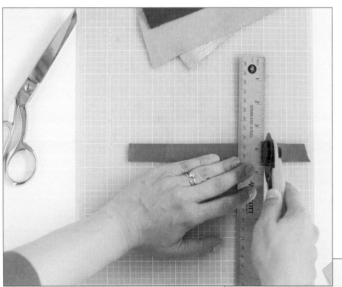

STEP 1
Use the rotary cutter and a ruler to cut your leather scraps into rectangles that are 6" x ¼".

STEP 2
Using a small craft knife, cut out letters or shapes from the contact paper. If you have a cutting machine (such as a Cricut), it's a great tool to make this step a little easier. If not, just cut slowly and carefully to ensure that your monogram has straight, clean lines.

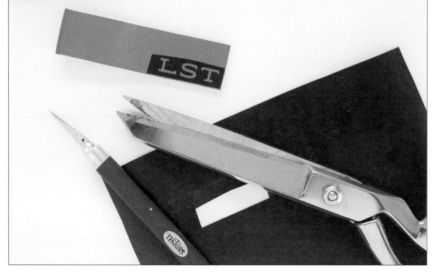

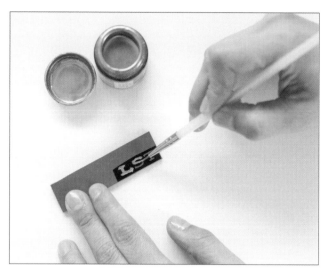

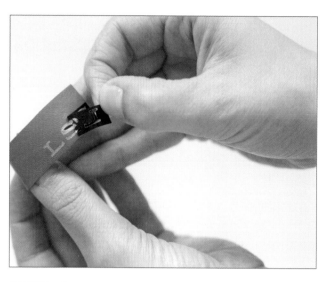

STEP 3

Remove the backing from the contact paper, and stick it to the leather where you'd like the monogram to appear. Press firmly to ensure that the contact paper is thoroughly adhered to the leather. Use a small paintbrush to carefully paint small strokes of liquid gilding on the monogram, using the contact paper as a stencil.

STEP 4

Wait about a minute for the gilding to dry slightly, and then carefully remove the contact paper to reveal the monogram underneath.

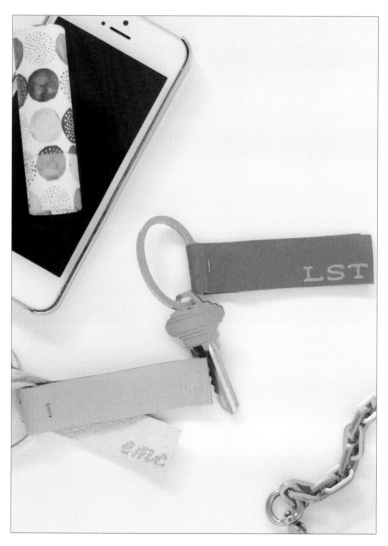

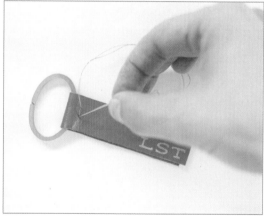

STEP 5

Once the liquid gilding is completely dry, insert the leather through the key ring. Fold it in half and sew a small stitch through both sides of the leather. Sew two to three stitches or until the leather is secured. Knot the thread on the backside of the leather, and trim the ends. Add your keys to the key ring, and give your new gilded leather monogram key fob a whirl!

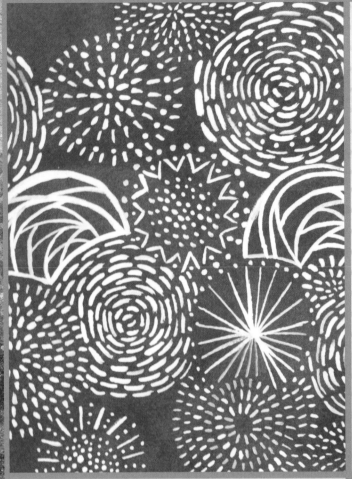

THE GREATEST PLEASURE IN LIFE IS DOING WHAT PEOPLE SAY YOU CANNOT

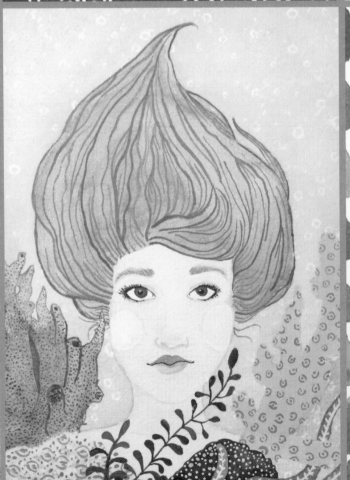

section Two

GABRI JOY KIRKENDALL

GABRI JOY KIRKENDALL IS THE ARTIST and founder of Gabri Joy Studios. She has worked with companies such as Minted and Threadless and has had the pleasure of working with clients all over the world, from such places as far-flung as Australia, England, and Spain. She specializes in watercolor painting and hand lettering and recently co-authored the book *Creative Lettering and Beyond.* Gabri hails from the Pacific Northwest, where she lives with her husband and her adorable puppy. Most days you can find her painting with her puppy on her lap and a very large mug of chai tea. To see more of Gabri's work, visit www.gabrijoystudios.com.

Gouache FOIL PAINTING

GOUACHE IS MOST COMMONLY USED in conjunction with watercolor paint, but it can shine just as brightly on its own, especially the metallic shades. In this tutorial we'll use primitive painting techniques to create striking art.

MATERIALS
- Watercolor paper
- Metallic gouache
- Paintbrush

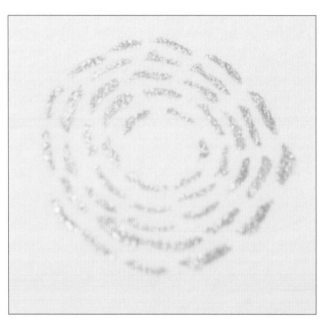

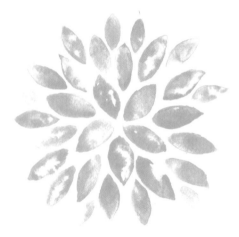

STEP 1
Using gold metallic gouache, begin by painting small dashes in concentric circles, moving outward.

STEP 2
Continue painting dashes until they are as long as you would like them be.

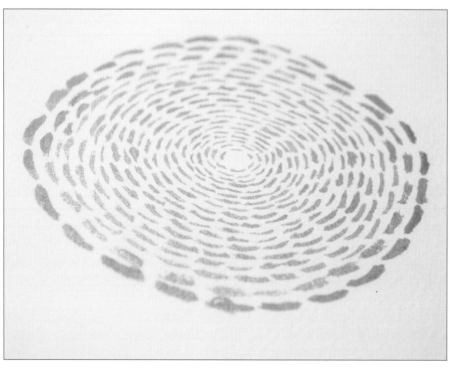

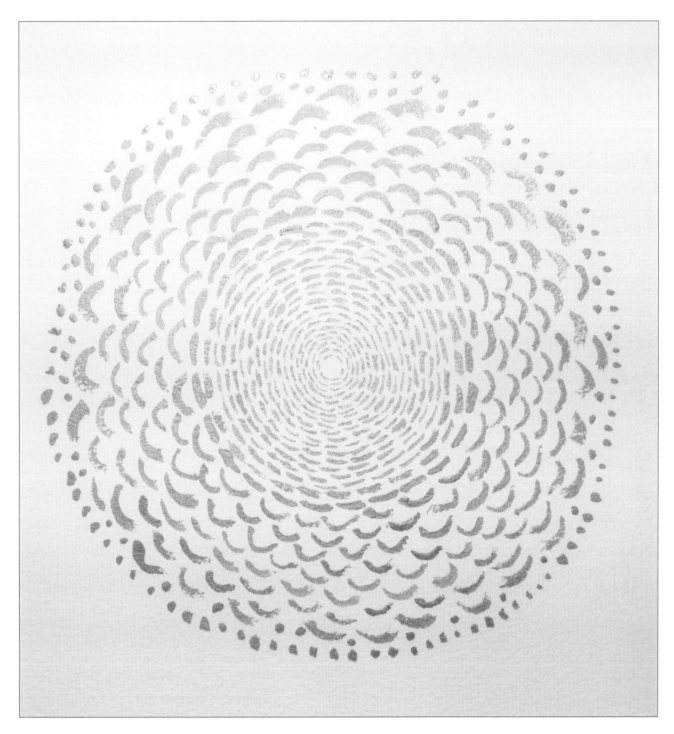

STEP 3

Continue creating strokes, but alter them to create contrasting depth. I used rounded half-shell strokes and ended with a circular row of small dots.

Allow the paint to dry completely

before hanging your new piece to avoid smudging.

Watercolor RAINDROPS

A GREAT WAY TO PRACTICE TECHNIQUE—and create some cool patterned art at the same time—is to use a favorite shape. I picked raindrops because they remind me of the cool, damp weather of my beautiful Pacific Northwest, with one tiny drop hinting at the promise of warmer days.

MATERIALS
- Watercolor paper
- Pencil & eraser
- Watercolor paints
- Paintbrush

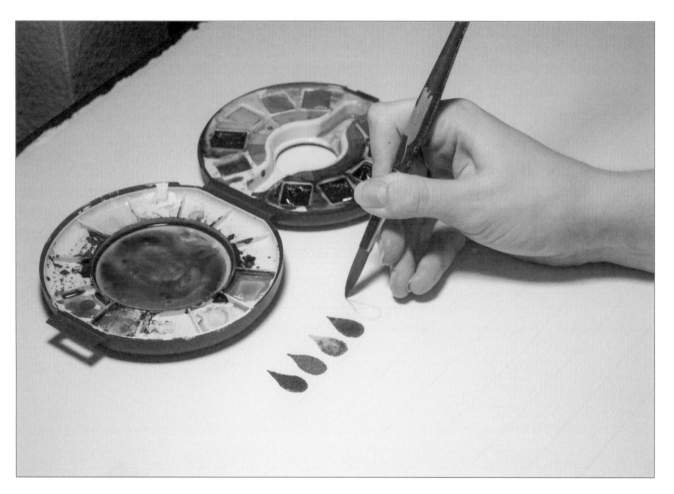

STEP 1

Use a pencil to sketch light, straight, evenly spaced lines on watercolor paper. Then begin to paint each shape, keeping the spacing between each one even. On some of my raindrops I use an even layer of color; on others I paint a lighter background and then drop in darker bits of paint to create a cool feathered effect.

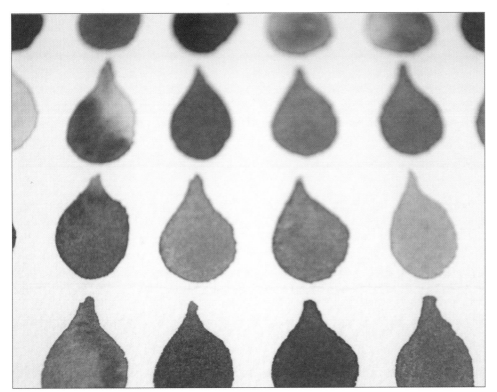

Keep working to fill each row with evenly spaced shapes. I used a combination of cobalt, ultramarine, and black to paint my raindrops.

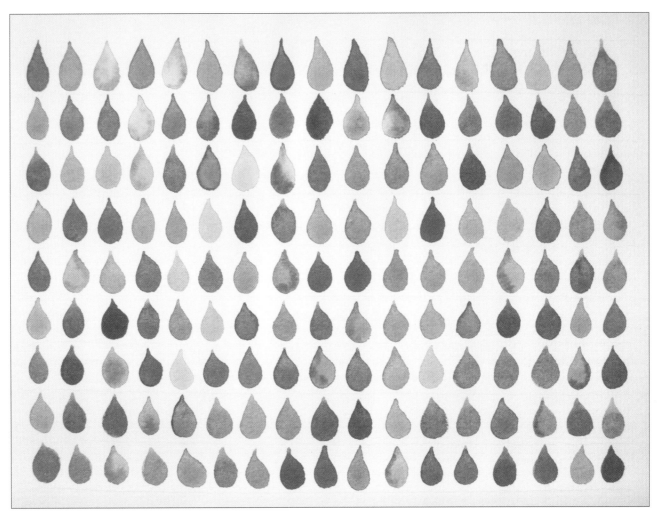

STEP 3

Choose one shape to paint a different color. I used a bright, sunny peach color on a solitary drop. Paint the rest of the shapes in the same colors. Let the paint dry, and then erase the pencil lines!

Gouache ILLUSTRATION

GOUACHE LENDS BEAUTIFUL contrast to artwork, and it is also perfect for adding patterns and details on watercolor. Just remember to use a fine-tipped brush for smaller details!

MATERIALS
- Watercolor paper
- Pencil
- Watercolor paints
- White gouache
- Paintbrushes

STEP 1

First sketch the outline of feathers. Then paint inside the outline first with water, which will help the watercolor paint blend well. While the paper is damp, begin adding color.

STEP 2

Continue adding color, painting wet-into-wet to keep the colors blending smoothly together.

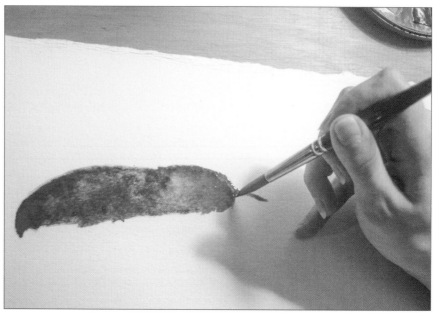

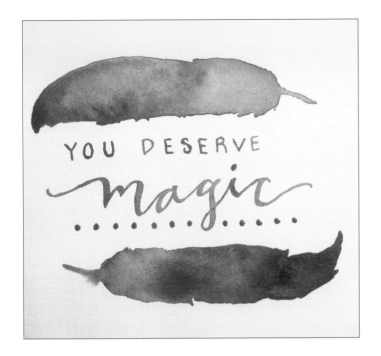

STEP 3

Repeat the process to paint the second feather. Let the feathers dry, and then hand-letter a message in the middle.

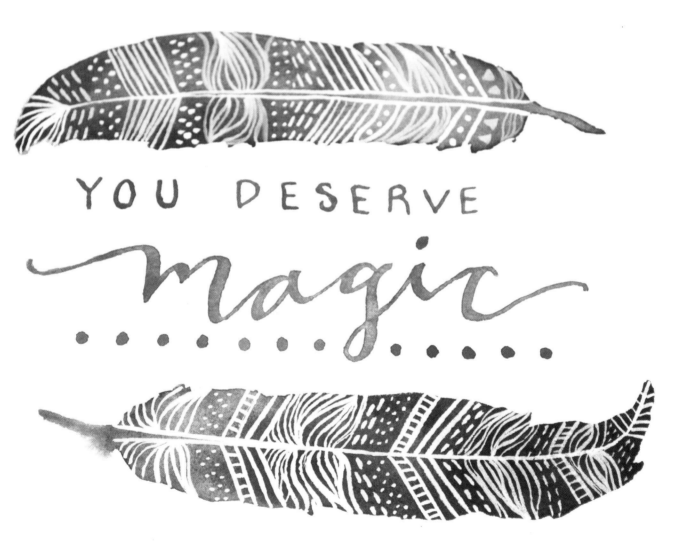

STEP 4

Use white gouache to add detail and pattern to the feathers. The effect is beautiful!

Tribal Gouache LAYERING

GOUACHE IS A VERSATILE PAINT that can be used as the primary medium for a painting, but it can also be mixed with watercolor paint to create varying semi-opaque shades. Tribalism is a genre that uses bold colors and sharp geometric shapes. In this tutorial we'll use gouache to create an abstract tribal piece.

MATERIALS
- Watercolor paper
- Watercolor paints
- Gouache paints
- Paintbrushes

STEP 1
Begin by painting the background. I used a very light, almost-mint watercolor wash.

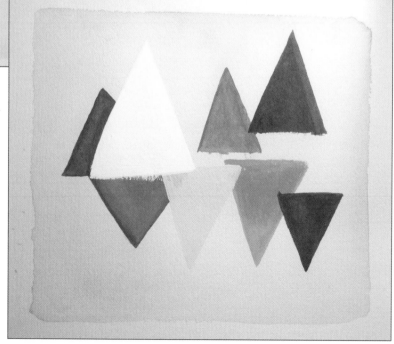

STEP 2
Allow the background wash to dry, and then begin to layer with gouache. I started by painting a series of triangles in varying sizes and opacities on the background. Don't worry about the edges in the middle being perfect right now.

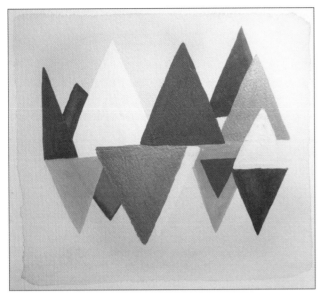

STEP 3

After the first layers of gouache are dry, continue with a new layer. In this second layer I added my boldest, brightest colors: a rich red and a metallic gold gouache that mimics the look of gold foil.

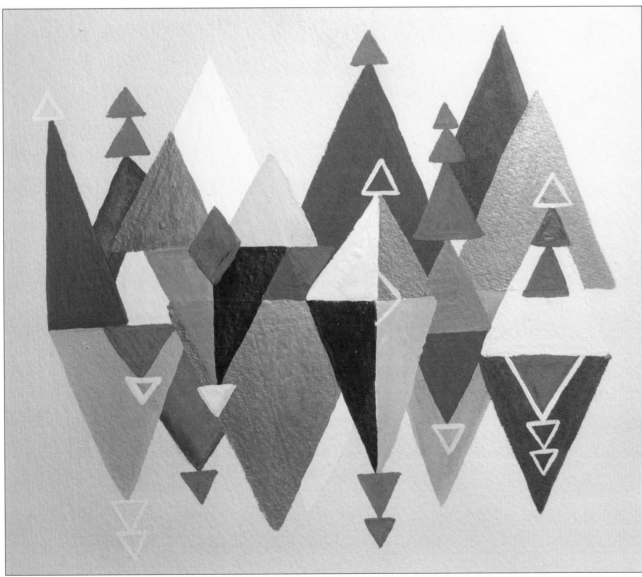

STEP 4

Let the gouache dry before adding a final layer. For this final layer I only used two colors—a bright cerulean blue and zinc white. With the blue I added small triangles, some stacked on each other, which reminds me of church spires rising over a city. Use white gouache to add some outlines as a final touch.

Gouache Lettering on WATERCOLOR BACKGROUND

UNLIKE TRADITIONAL WATERCOLOR PAINT, gouache has varying degrees of opaqueness. This allows you to paint over—and obscure—other layers of paint. When you study watercolor painting you learn to plan your painting in layers, starting from light to dark. Working with gouache allows you to take your paintings to a new level with an added degree of depth! I love to pair watercolor backgrounds with different colors of gouache for a stunning effect. Try it out!

MATERIALS
- Watercolor paper
- Watercolor paint
- Gouache paint
- Paintbrushes

STEP 1
Choose a shape for the background of your artwork, and paint the shape with water on watercolor paper.

STEP 2
Add watercolor paint, but don't go all the way to the edge of the shape. The wet paint on wet paper creates a cool feathered ombré look.

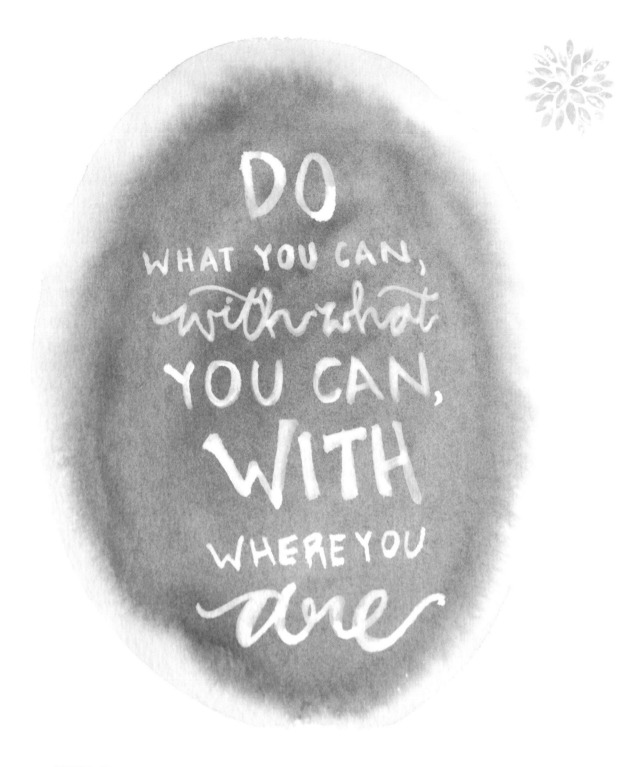

DO
WHAT YOU CAN,
with what
YOU CAN,
WITH
WHERE YOU
are

STEP 3

Let the watercolor paint dry. Select a quote, phrase, pattern, or design (mine is a quote inspired by Theodore Roosevelt). Then choose a contrasting color of gouache paint, and paint away. Allow the paint to dry.

Sketch or practice

your lettering or artwork on another piece of paper

before you begin applying the gouache.

Now that you've had some practice, take it to the next level by creating a more complicated background with greater detail.

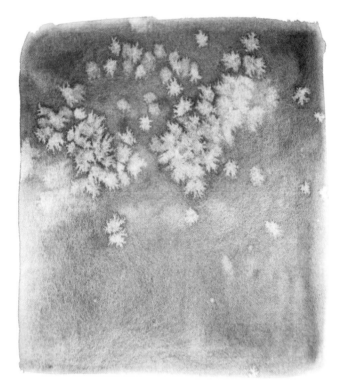

STEP 1

Begin with a light wash of your base color, using watercolor paint. To create a night sky like me, begin with a wet wash, blending different blues, a little black, and a touch of violet on wet paper. To create the starry effect, scatter salt across the top half of the page. Wait for the paint to dry completely, and then gently brush the salt off with your hand.

Salt is a great way to add texture to watercolor paint and is perfect for suggesting stars or snow!

STEP 2

Next begin to layer the bottom half of the painting, using black watercolor paint with varying amounts of water to create the illusion of hills stretching out into the distance. Allow the paint to dry completely between each layer, or the layers will bleed into each other.

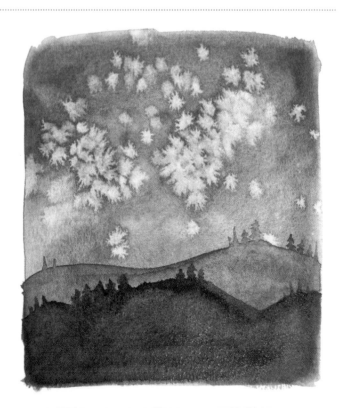

STEP 3

Let the background image dry completely. Then rinse your brush, and use white gouache to letter a quote or phrase of your choice.

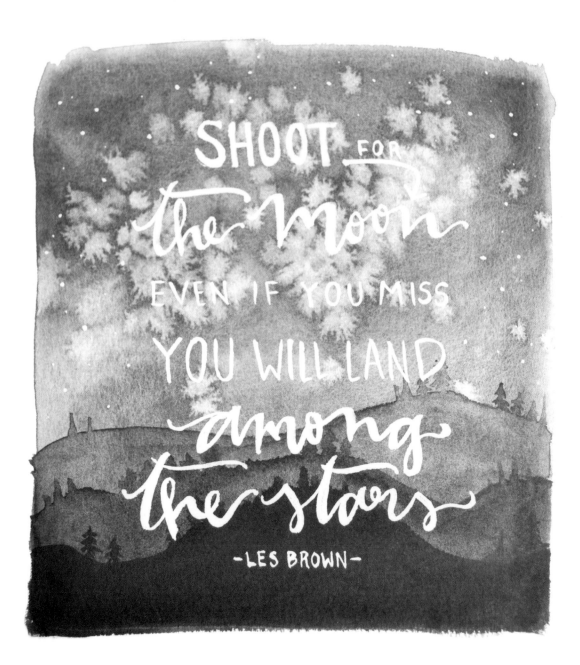

STEP 4

To complete the effect, dot a smattering of stars around the letters. Then step back, and enjoy your work!

Brush LETTERING

BRUSH LETTERING is a great painting exercise! This technique is rough and full of personality, which creates bold works of art.

MATERIALS
- Watercolor paper
- Pencil
- Medium and small paintbrushes
- Gouache paints

STEP 1
Begin by selecting a quote and creating a rough sketch on watercolor paper.

STEP 2
Next pick your paint and load your brush. To achieve the brush-lettering look, you want the brush to be on the dry side for added texture. Begin to letter by going over your pencil sketch one letter a time.

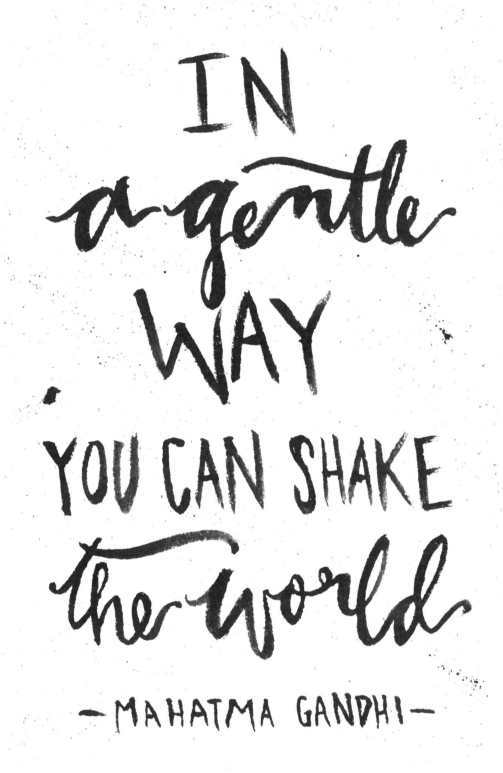

IN a gentle WAY YOU CAN SHAKE the world

— MAHATMA GANDHI —

STEP 3

When you have finished going over the lettering, add a dash of character with the splatter technique. Load a wet brush with paint, and use your finger to flick the tip of the brush over the paper.

Brush lettering is really fun and can definitely stand on its own. But if you are looking for a way to kick it up a notch you can start by adding watercolor illustrations.

STEP 1

Select a quote, and begin to brush letter. You can pencil it on the paper beforehand, but watercolor paint will not completely cover the pencil marks. Keep your wrist loose to create an easier, more natural look.

STEP 2

Next start adding the first layer of an illustration around the border. I'm creating a simple botanical border.

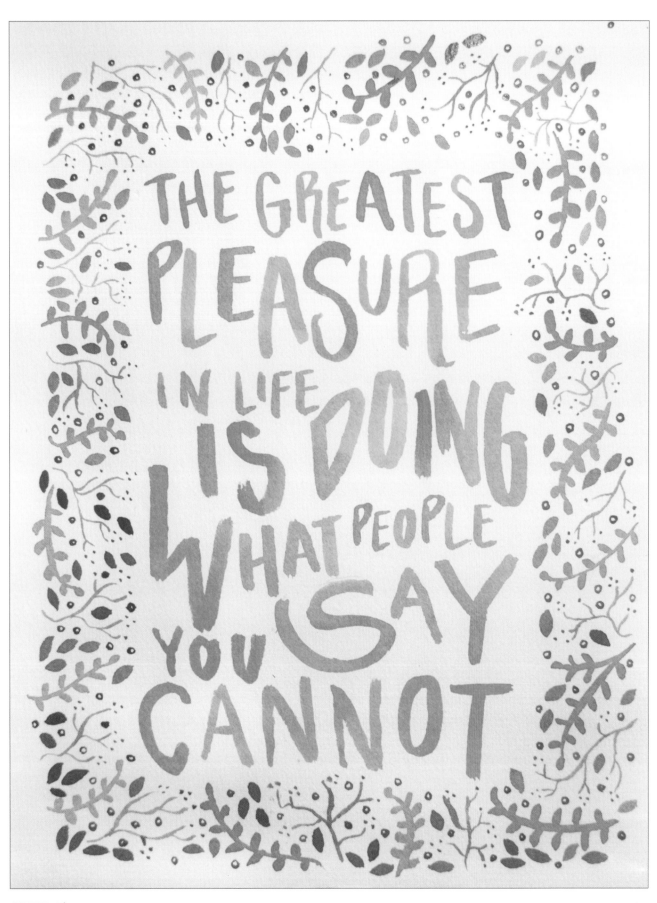

THE GREATEST PLEASURE IN LIFE IS DOING WHAT PEOPLE SAY YOU CANNOT

STEP 3

Build up the illustration in layers, pausing often to check the balance. Let the paint dry completely before framing or hanging your new artwork.

Converting Your Work
TO A DIGITAL FORMAT

OPEN YOURSELF UP TO A WHOLE NEW REALM of opportunity by digitizing your lettering and illustrations. All you need is a camera, a computer, and the photo-editing software of your choice. Once you learn to convert your work to a digital format, you can create any number of fun projects, including printing on fabric, creating your own temporary tattoos, and so much more!

MATERIALS
- White foam core board
- Digital camera (preferably a DSLR)
- Tripod (optional)
- Computer & photo-editing software
- Artwork

how to set up your photo shoot

LIGHT SOURCE (WINDOW OR LAMP)

STEP 1

Follow this illustration as a guide to set up your photo shoot. Choosing the light source is the most important thing. Natural light, such as an open window, works best. If that's not available, don't worry! You can purchase a full-spectrum light bulb or even tweak the white balance on your camera to achieve good light. Position the light source to the side so that it can reflect off the foam board and light up your subject.

STEP 2

Once you snap a couple of good photographs and load them onto your computer you are ready to start editing. Select your favorite image, and open it in your photo-editing software. I'm working in Photoshop®.

STEP 3

Create a new layer. To do this in Photoshop, click on "Layer," "New," and then "Layer."

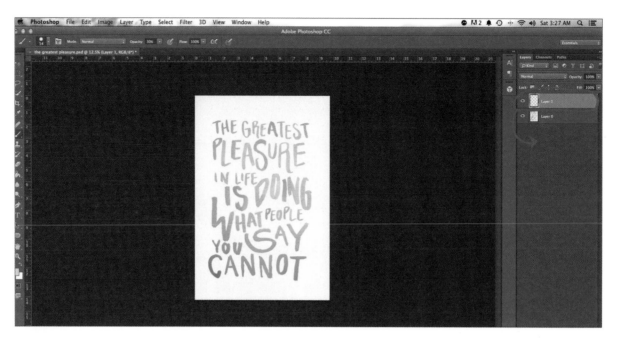

STEP 4

In the layers palette on the side, click on the new layer and drag it down below the original image layer.

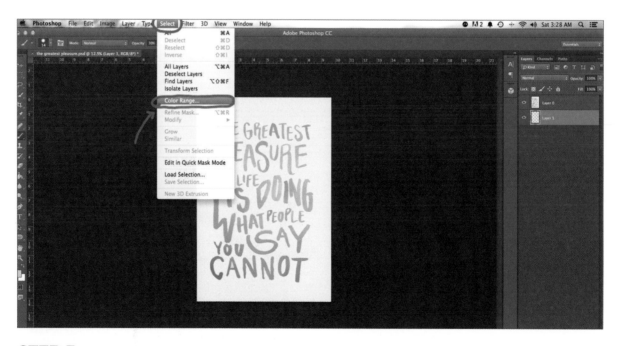

STEP 5

In the top menu click on "Select" and then "Color Range" to open the "Color Range" window.

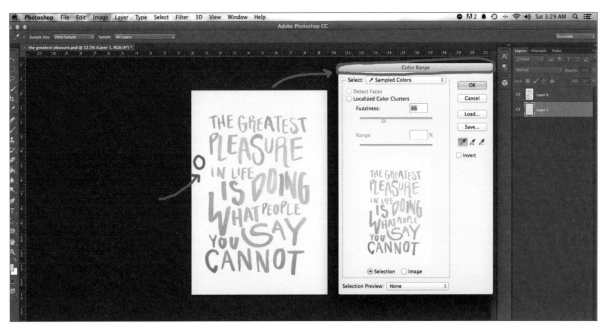

STEP 6

Use the eyedropper tool to click on the background of the picture.

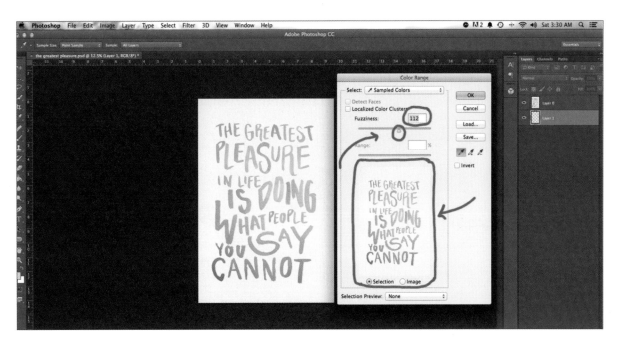

STEP 7

Once the background is selected, use the fuzziness slider to increase or decrease the contrast and the number of pixels selected. This determines how sharp the letters or illustration will be once you delete the background.

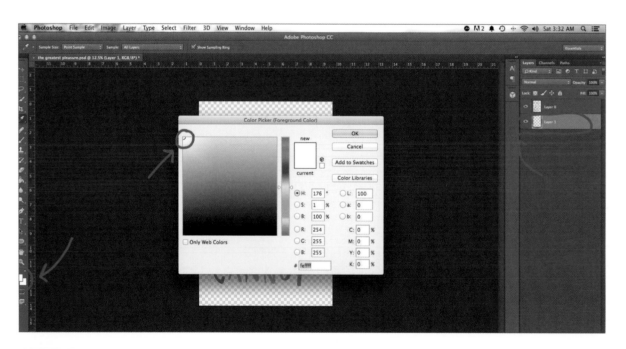

STEP 8

When you are satisfied, hit the delete key on the keyboard, and the background will disappear. Go back up to "Select" in the top menu, and click "Deselect."

STEP 9

Click on the top box of the color selector at the bottom of the toolbar. The color selector will open, and you can choose a background color.

STEP 10

Click on the layer you created in step 3 (Layer 1). Using the paint bucket tool, click on any part of the background to insert the new background color.

If you would like to be able to insert or drop your illustration over a different background, click on the small eye icon next to Layer 1 to make it invisible. Then save your work.

Open the new background image, and drag and drop your illustration file onto the new open file to create a new layer. You can customize the size and placement of the illustration. Then save your work!

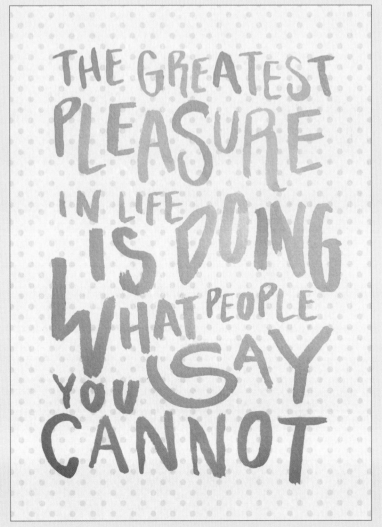

Temporary TATTOOS

AFTER CONVERTING your lettering or illustration to digital format, try making these fun DIY temporary tattoos!

MATERIALS
- Illustrations
- Tattoo printing paper
- Scissors

Choose the Type of Tattoo paper that corresponds to your printer. For example, the tattoo paper I use is for inkjet printers. Each kind of tattoo paper comes with its own instructions for application.

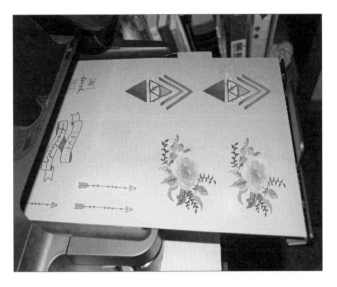

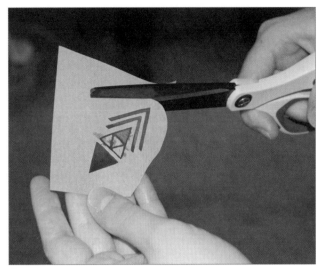

STEP 1

Prepare your printer to print onto the tattoo paper. Read the tattoo paper instructions carefully, as you might have to recalibrate your printer for a paper with a different texture and weight. You also want to check to ensure it will print on the right side of the paper! Once you're set, print your illustration. Allow the ink to dry fully.

STEP 2

Cut around your design so that the tattoo is easy to apply.

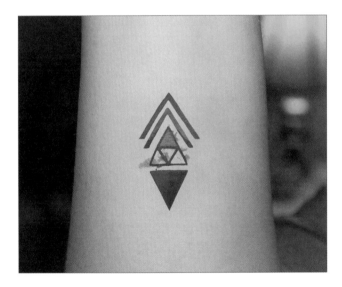

STEP 3

Apply the tattoo onto a clean area of skin with the ink side facing the skin. When applying the tattoo, start at one edge and gently roll the design gradually onto the skin to avoid creases. Enjoy your hot new tattoo!

You may also want to use

a washcloth and warm water to clean the area of skin before applying.
This will help the tattoo last longer.

Abstract Watercolor
PAINTING

WATERCOLOR IS A FLUID MEDIUM that lends itself well to experimentation and abstract thinking. I love abstract painting because of the raw emotion it conveys. Using watercolor teaches you to paint in layers. In this painting technique we'll start with lighter colors and layer on darker colors for effect.

MATERIALS
- Watercolor paper
- Watercolor paints
- Gouache
- Paintbrushes

STEP 1

In order to create a soft, feathered effect, start by painting a rectangle of water for the background. Then begin to layer soft color on top and watch it feather outward. Allow the paint to dry.

STEP 2

Next begin to layer brighter colors in smaller shapes to complement the background.

STEP 3

Let the paint dry, and then add a final layer, with bright contrasting colors and patterns!

Abstracts are so versatile—they can stand on their own or be used for any number of projects, from hand lettering to temporary tattoos!

STEP 1
Begin with the lightest layer first, and paint a series of overlapping circles in various complementary shades.

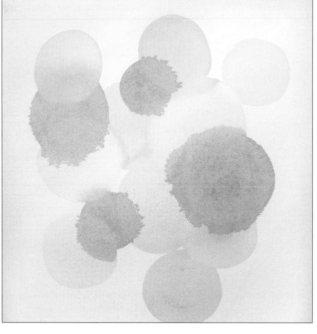

STEP 2
While the paint is wet, add darker circles on top, allowing them to feather into the lighter circles.

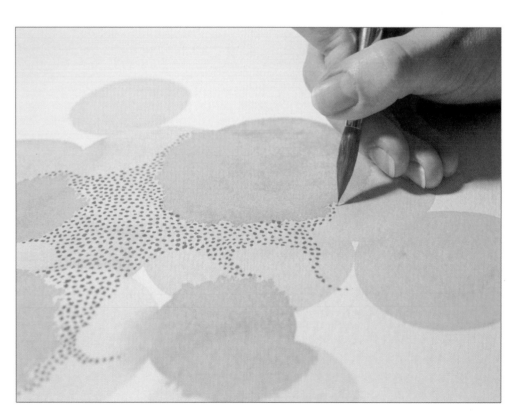

STEP 3
Next use red gouache to stipple a pattern between the circles.

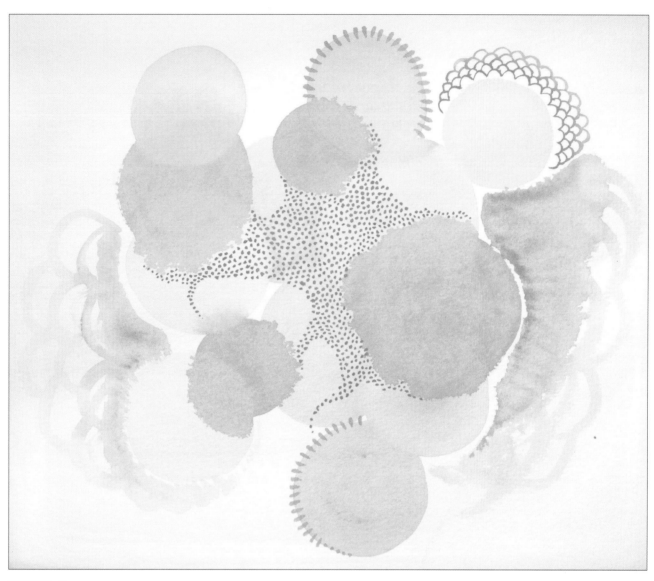

STEP 4

Allow the gouache to dry. Then use a combination of red watercolor and gouache paints to add more details to the painting. To finish, add light, free strokes of watercolor to create some lacy edges.

Try this technique with a defined shape. My
favorite geometric shape is the triangle, which may
seem simple, but is found recurring in nature in
great complexity! I like to use geometry to map out
constellations in the night sky. This tutorial is all
about trying to capture a small part of this beauty.

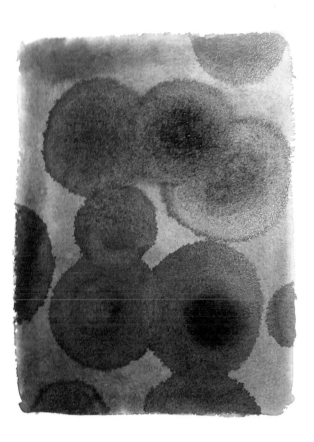

STEP 1

Start by painting a
rectangle of water and
adding layers of blue and
black shades of paint. Let
the paint dry completely.
Next layer circles of
darker shades of blue.

STEP 2

Once the circles are dry,
use white gouache and
a sponge to create a
mottled effect.

STEP 3

Then use white gouache to begin
painting a grid of connected
triangles, stretching from the top
right corner to the bottom left
corner of the painting.

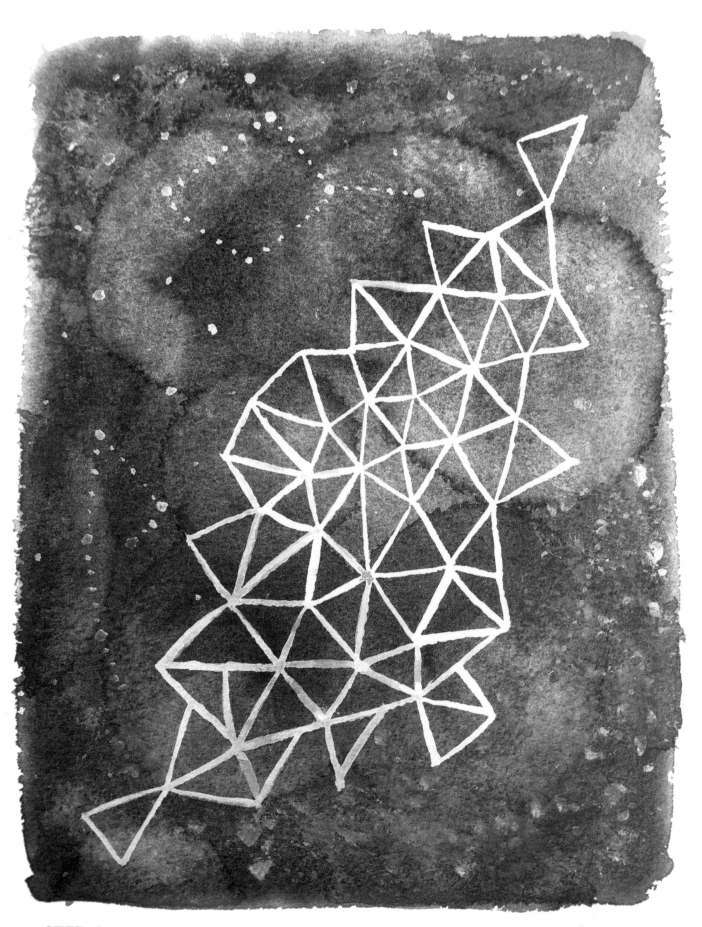

STEP 4

To finish, use gold metallic gouache to paint in stars and constellations, using differing sizes of dots around the edges of the triangular grid.

Abstract
FIREWORKS

ABSTRACT AND TRIBAL ART is very in vogue. Large statement pieces are perfect for the spot in your home where you want to make a bang! Use varying basic brushstrokes in different orders and patterns, but all in the same shape, to create interest and texture.

STEP 1

Start by painting the background in a consistent wash—I chose a deep medium blue. Allow the wash to dry, and then use different shades of paint on top of each other in concentric circles, allowing the paint to blend while wet. Do this four or five times, allowing each layer to dry in between.

STEP 2

Next prepare gouache. I chose to use zinc white gouache for a bold effect. Begin in the middle and create circles, using a different brushstroke to create each shape.

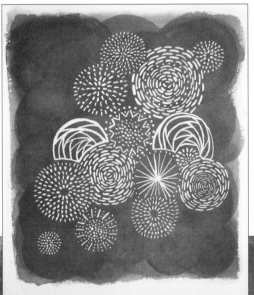

STEP 3

Continue to paint designs in expanding circles. Vary the size of the circles for interest.

STEP 4

Continue painting until you are happy with the design. I chose to frame the larger middle group of circles with smaller circles in the upper right corner and the lower left corner in order to create an illusion of a diagonal. Once the paint has dried you are ready to crop and frame your piece!

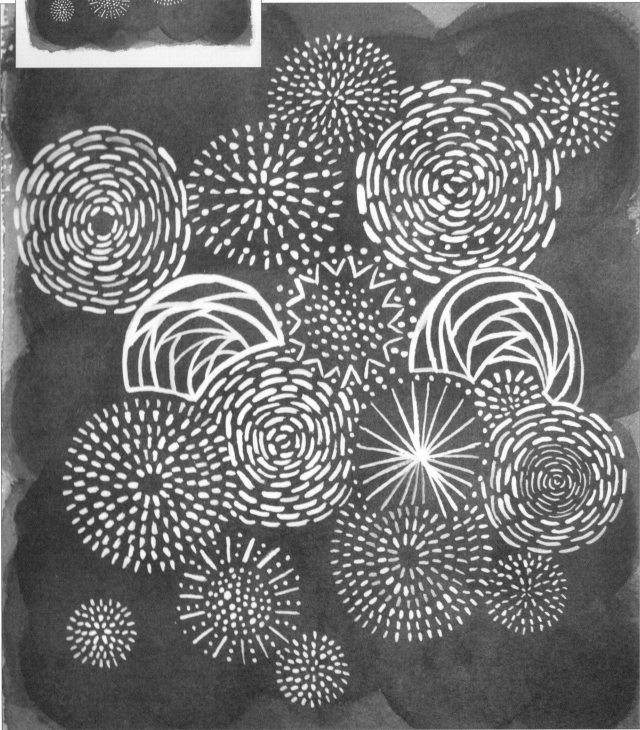

Floral
WATERCOLOR

THERE IS NOTHING SO CLASSIC and beautiful as flowers, and the history of art is overgrown with floral still life! I prefer a more abstract representation, rather than pure realism. A pretty floral piece can stand alone or provide a beautiful background for another project.

MATERIALS
- Watercolor paper
- Watercolor paints
- Metallic gouache
- Paintbrushes

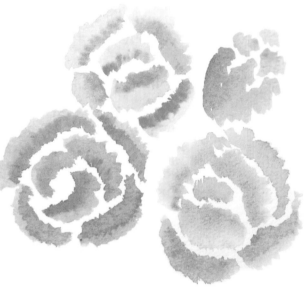

STEP 1

Begin by selecting the flower and colors you wish to paint. I chose roses in shades of pink and champagne and used a feathered brushstroke followed by a darker color on the inside of each petal to create depth.

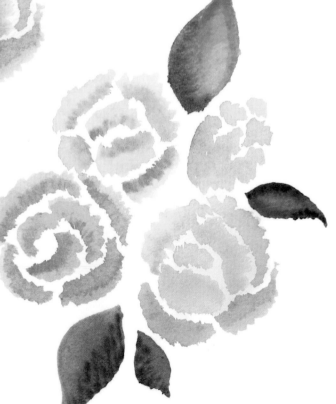

STEP 2

Next begin painting leaves. I start with larger, brighter leaves close to the roses, framing them. First I paint the outline and fill it in with paint. Then, before the paint dries, I add stripes in a darker shade to simulate the folded nature of the leaves.

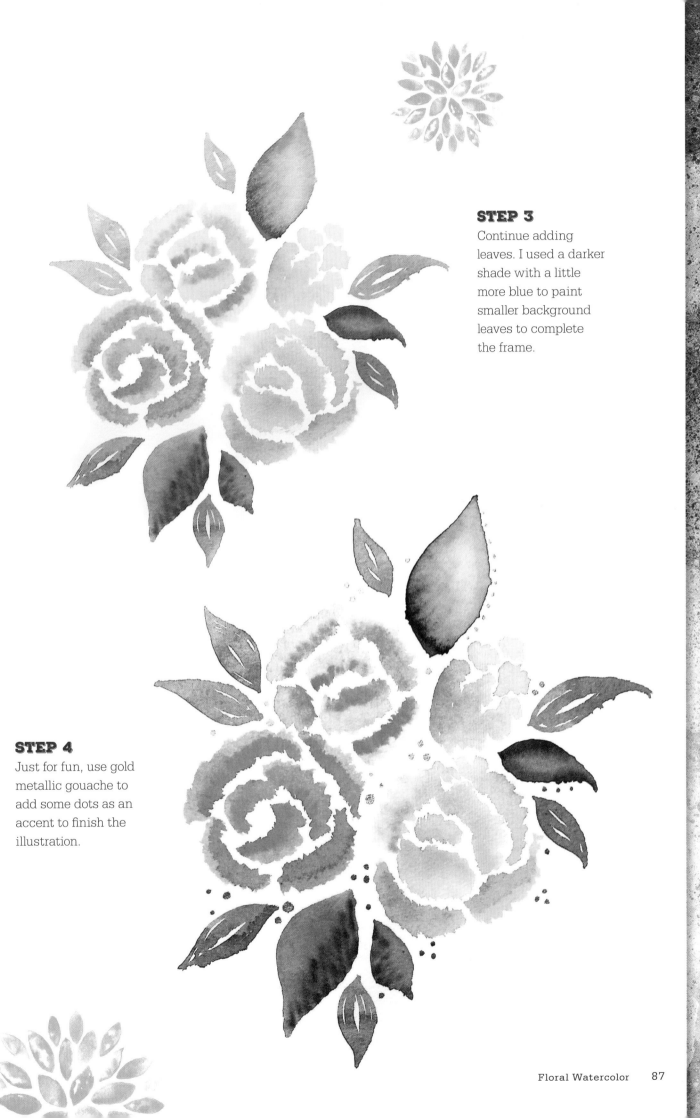

STEP 3

Continue adding leaves. I used a darker shade with a little more blue to paint smaller background leaves to complete the frame.

STEP 4

Just for fun, use gold metallic gouache to add some dots as an accent to finish the illustration.

Golden
MOTH

I LOVE FINDING WAYS to layer gouache over watercolor for stunning effects, especially when using gold metallic gouache paint, which creates a foil effect. For this tutorial I chose to illustrate a golden moth.

STEP 1

Begin by sketching the shape of the moth. Then use watercolor paint to begin. I chose a beautiful sunset palette to complement the gold gouache. I paint the top of the top wings a light yellow and add an orange stroke along the bottom while the paint is wet to allow the colors to blend.

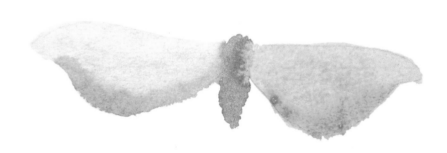

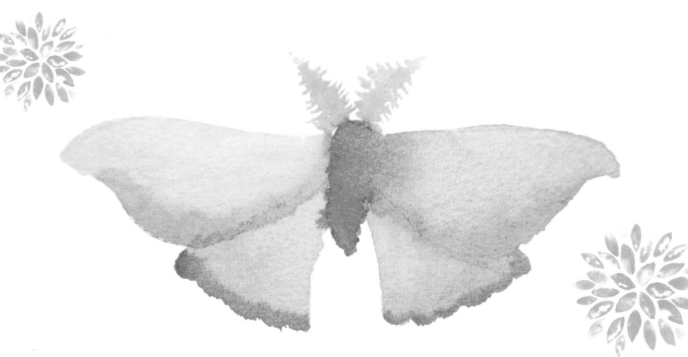

STEP 2

Allow the paint to dry. Then paint the bottom wings in the same manner. I used light pink and dark pink. Add feather antennae at the top with less diluted yellow paint. Let the paint dry.

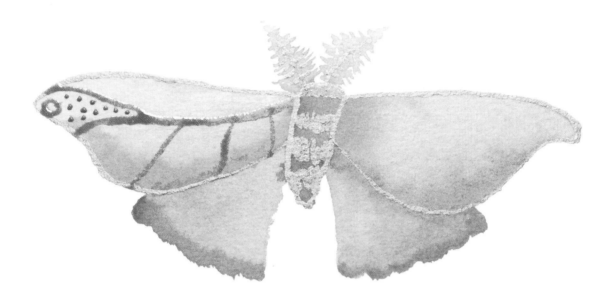

STEP 3

Pull out the metallic gouache and begin to paint, working from the outside in. I start by painting the edges of the moth first. Then I begin filling the wings with pretty designs.

> ➤ *If you use too much water* ◄
>
> with metallic gouache the paint may separate.

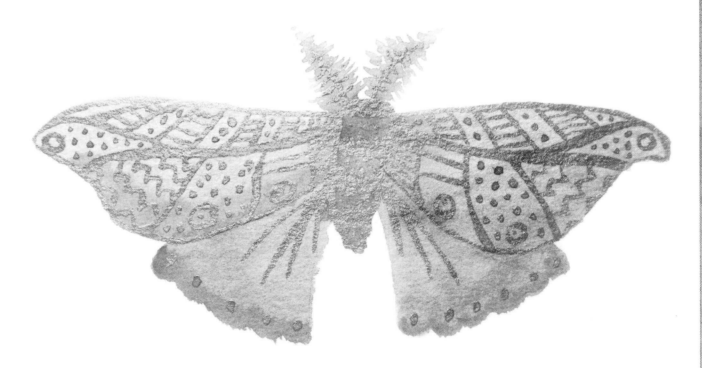

STEP 4

Finish painting the gouache pattern. I only added a few simple details to the bottom wings, allowing the top wings to take center stage. Let the gouache dry completely, and then step back and enjoy the effect!

Underwater ILLUSTRATION

NOW THAT YOU'VE BUILT UP your illustration skills, it's time to take it to the next level. For this tutorial I've combined my love of the ocean and coral reefs. Painting an underwater scene provides many opportunities to paint layer upon layer for a complex painting using watercolor and gouache. Let's go for a dive!

MATERIALS
- Watercolor paper
- Pencil
- Watercolor paints
- Gouache paints
- Paintbrushes

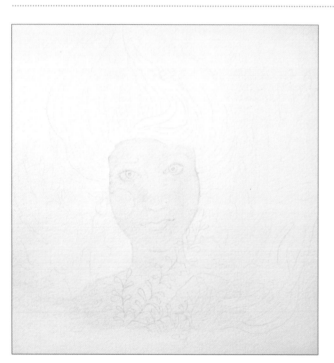

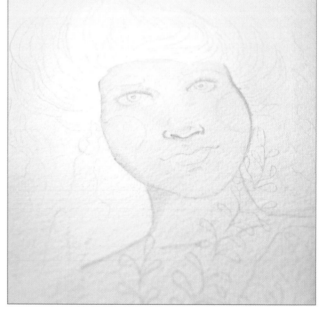

STEP 1

Begin by sketching the scene lightly with a pencil. I recommend using a harder lead so that the pencil marks don't show through the watercolor in later stages. Then apply a skin-colored wash over the girl's head and chest. Don't be afraid to overrun the borders a bit at the bottom; you will paint over it in gouache later.

STEP 2

Begin to add depth and shadow to the face. I chose a gray-blue color, since any underwater shadows would appear bluish in tint. Use shadows to outline the shape of the nose and the bridge. Add a little dark color on the eyelids to bring depth to the eyes. To achieve light shadows, paint the shadow first; then dab the brushstroke once with a cloth, lifting up paint. This technique produces a slightly mottled effect that is perfect for imitating the texture of skin.

STEP 3

Use white gouache paint to highlight the light parts of the face, including the brow bones and the whites of the eyes. Because my sketch has a doll-like look, I also paint the inside of the cheeks white.

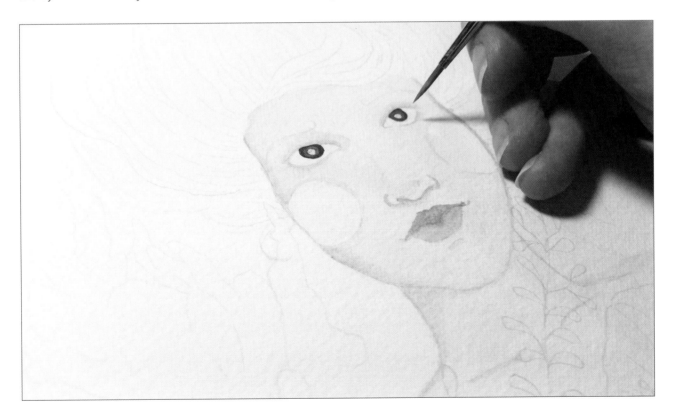

STEP 4

Next paint the irises, using a few colors. Be sure to leave a spot on each iris for light reflection. While the paint dries, add some color to the lips with soft pink, as well as a touch of color around the edges of the cheek circles. If needed, you can add another layer of paint on the irises.

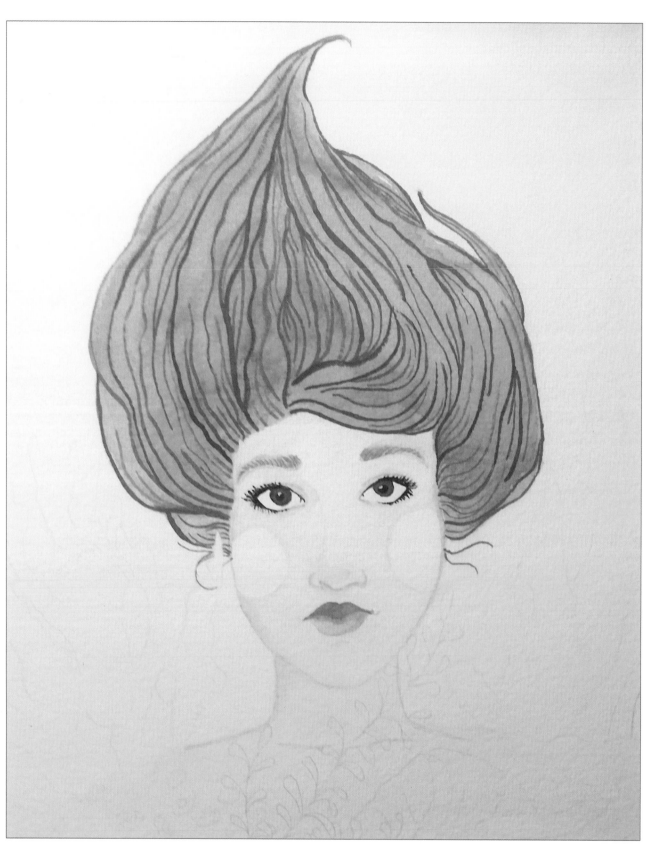

STEP 5

Next paint the hair. I started with a bright red watercolor wash. Once dry, I mixed darker red gouache to stroke in some individual hairs, using a small brush. Keep your wrist loose as you paint to achieve smooth, confident sweeps reminiscent of the way hair floats underwater. Repeat this process on the eyebrows, using short strokes for the hairs. Then add a fringe of eyelashes to both eyes and fill in the pupil with black paint.

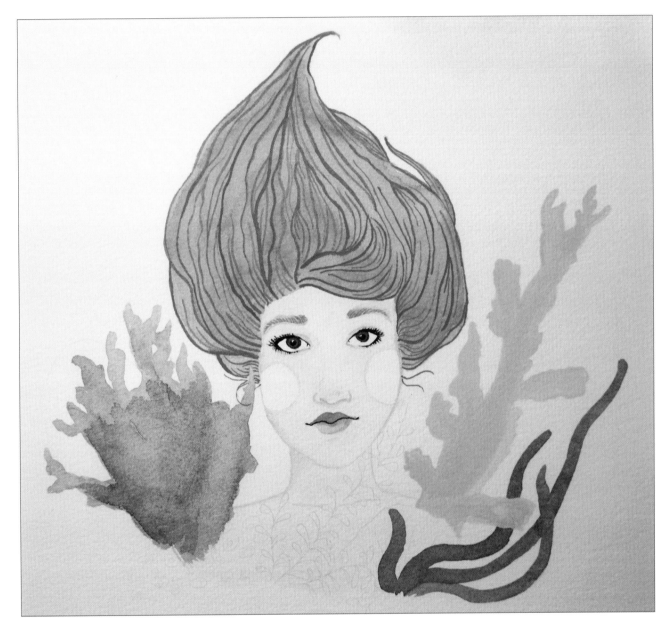

STEP 6
Start on the coral, painting a simple background color for each piece first. Let the paint dry.

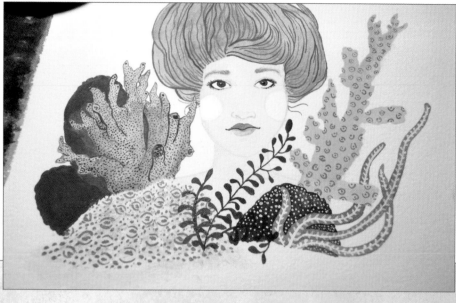

STEP 7

When the background colors are dry, use gouache to add details to the coral. You can use various sizes of dots, strokes, and other shapes to add detail and interest. Then add a delicate, waving piece of kelp to finish framing the face. I used a deep merlot gouache.

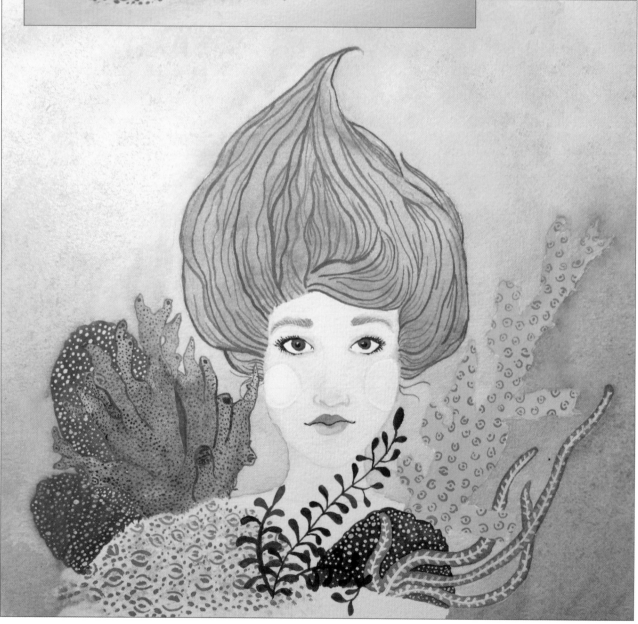

STEP 8

Allow the paint to dry. Then paint the water. I used a simple, light turquoise watercolor wash. When the paint is dry, you can trim the artwork to define the borders as you finish the painting.

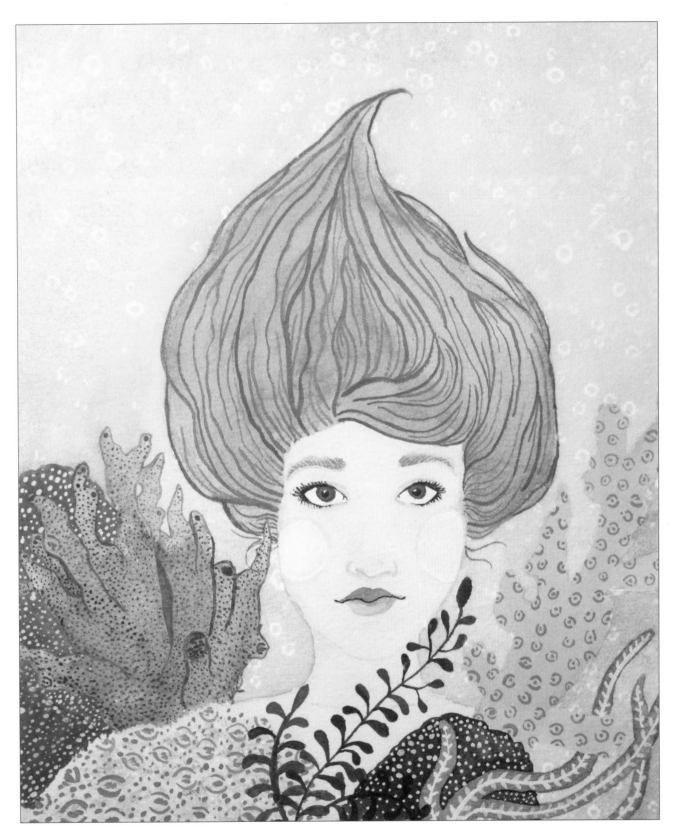

STEP 9

Add water bubbles for a final touch. Water down white gouache. Then use a small straw to carefully suck up a small amount of paint. Don't suck too hard, because you want the paint to remain at the bottom of the straw! Gently blow through the straw over the area where you want bubbles. This technique creates actual bubbles on the paper; when they pop, they leave bubble marks! Use another piece of paper to cover areas of the painting you want to protect as you blow the bubbles. Let the paint dry, and your masterpiece is complete!

Watercolor & Gouache INVITATIONS

NEED A STUNNING AND UNIQUE invitation for your next dinner soiree? Birthday party? Bridal shower? You can create stunning stationery that your family and friends will "oohh" and "aahh" over!

MATERIALS
- Watercolor paper
- Paintbrushes
- Watercolor & gouache paints
- Pencil

➤ *You can either* ◀

hand letter the words or upload your design and add them digitally before printing.

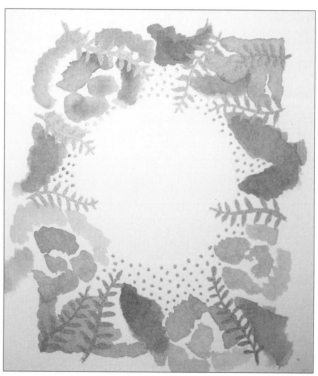

STEP 1

First sketch the outline of your invitation in pencil. I also chose to trace a circle in the center to leave blank for the words. Then begin to paint. I painted abstract tropical flowers and leaves in bright colors, using watercolor paint.

STEP 2

Allow the paint to dry. Then use gold gouache to add details. I painted gold ferns and tiny gold dots to fill the space between the flowers and outline the middle circle.

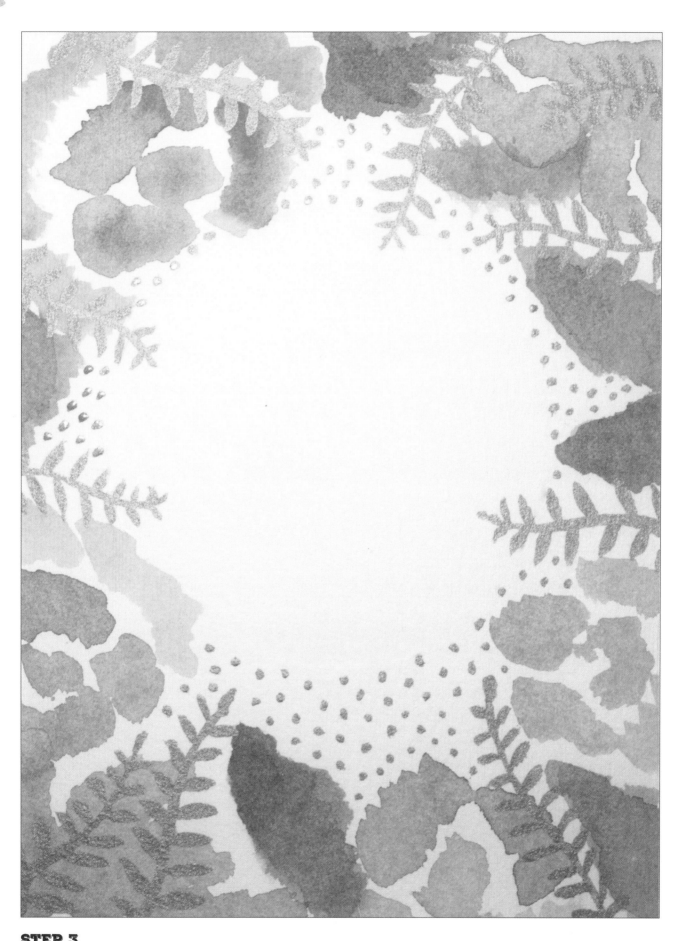

STEP 3

Once all the paint is dry, erase the pencil lines. Now you can crop the invitation to create clean edges, and your template is ready to use!

Watercolor can be a stunning backdrop for many things, but my favorite is paper goods. After you've painted your design, your next beautiful invitation is just a few clicks away!

STEP 1

Start by painting a large ombré wash, starting with fuchsia and ending in a sunburnt orange for a sunset look. Let the paint dry.

STEP 2

Next use gold gouache to paint a border for the invitation. I'm outlining mine with gold vines in a tall rectangle.

STEP 3

Complete the border. Then add a smattering of gold dots to further define the border and add some textural difference.

STEP 4

Once the paint is dry, you can either take a high-resolution photograph or scan the painting and load it onto your computer. Use photo-editing software to crop the image, and your invitation is ready for text!

Watercolor HOUSE PORTRAITS

WHAT BETTER WAY to commemorate your home, the scene of so many fond memories, than by trying your hand at a fun house portrait? Give it a try. They make great gifts too!

MATERIALS

- Watercolor paper
- Watercolor paints
- Paintbrushes
- Pencil
- Archival ink pen (optional)

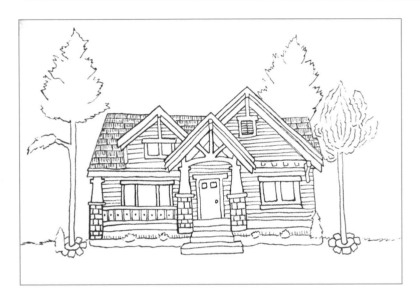

STEP 1

Begin by sketching your house. I decided to make the sketch bolder by inking over it with a .35mm archival ink pen.

STEP 2

Next add subtle details and stippling to give your house and its surroundings texture and depth. I used stippling in the flower beds and irregular lines to simulate tree bark. For a personalized touch, add the date you moved into your home.

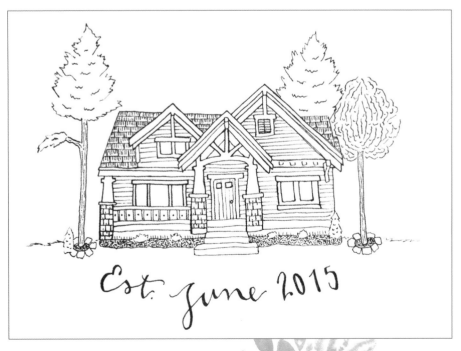

Est. June 2015

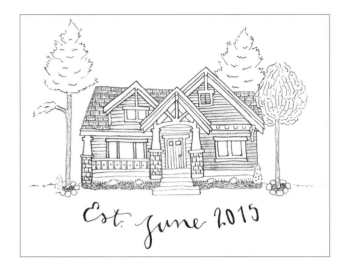

STEP 3

Now get ready to paint! Begin with a basic background color for the house. I created more texture by painting with excess water and then carefully patting off the excess with a paper towel.

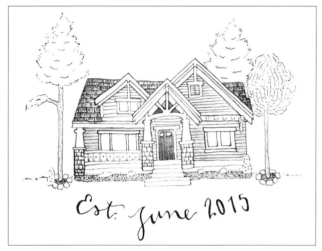

STEP 4

Paint the door and any other features with a foundation color.

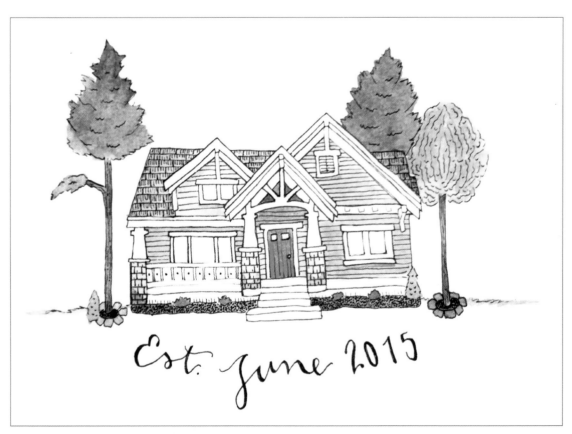

STEP 5

Once the paint is dry, finish the portrait by adding final small details and shading to the house. Then paint the surrounding landscaping.

section three
ALIX ADAMS

ALIX ADAMS IS A BLOGGER, event planner, and DIY enthusiast. From the time she could hold a glue stick in her hand she has set out to make the world a better place with crafts, parties, and a bit of ice cream. Alix runs *A Ruffled Life*, a lifestyle and design blog all about crafting a handmade and heartfelt life. She also blogs for HGTV Design Blog, Home Depot, and The Neighborhood. To learn more, visit www.aruffledlife.com.

Painted PILLOW

PAINTING ON FABRIC IS A FUN, inventive way to add personality to your home or craft projects. And painting on fabric is an easy technique to learn! These initial canvas pillows are the perfect personalized addition to a bedroom or throw pillows for a couch!

MATERIALS

- 2 equal-sized squares of canvas fabric*
- Canvas fabric strip, cut to 6" wide and six times the width of the fabric squares in length (e.g. if the fabric squares are 12", the strip length should be 72")
- Painter's tape
- Fabric paint or acrylic craft paint
- Paintbrush
- Fishing wire
- Sewing machine
- Pillow form or batting

*Note: You can use a plain, pre-sewn canvas pillowcase if you wish.

STEP 1

Use painter's tape to create an outline of the initials or design on one of the fabric squares. Press firmly to apply the tape to prevent paint from seeping under it. For rounded edges, place small pieces of tape in a slightly curved pattern.

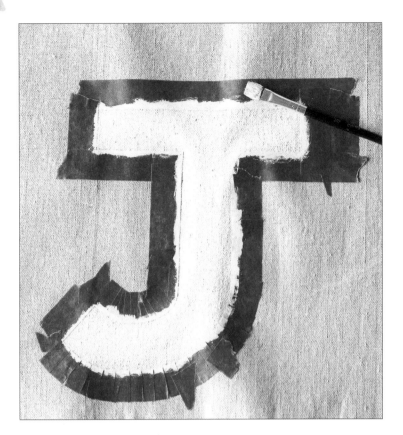

STEP 2

Fill in the outline with paint, slightly overlapping the tape to create a crisp edge around the letter. A thick coat will ensure a vibrant design!

If you're using a pre-sewn pillowcase, put a piece of cardboard inside to prevent the paint from bleeding through the fabric.

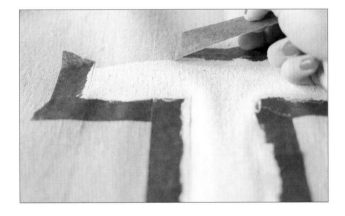
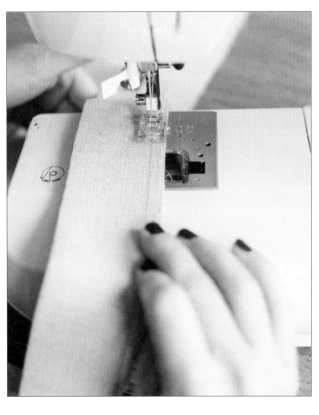

STEP 3

Allow the paint to dry completely. Then carefully remove all the tape, pulling it off at an angle. If you used a pre-sewn pillowcase, you're done!

STEP 4

To create the pillow ruffle, first fold the long strip of fabric in half width-wise to create a 3" fold. Sew the open edge of the fold with a piece of fishing wire.

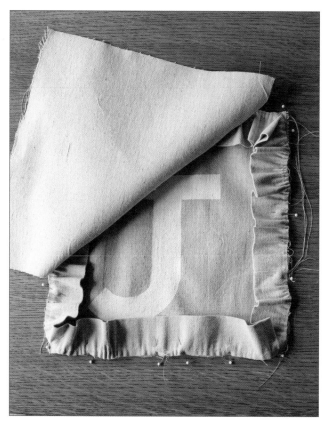

STEP 5

Then gather the fabric strip along the fishing wire to create a ruffle effect.

STEP 6

Next lay the painted fabric square faceup. Place the fabric ruffle around the perimeter of the fabric square with the sewn ruffle edge on top of the square's edge. Place the unpainted fabric square on top of the ruffle, and pin the three pieces together.

STEP 7

Now sew the three pieces together, leaving a 6" gap unsewn. This will create an inside-out pillow.

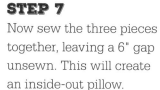

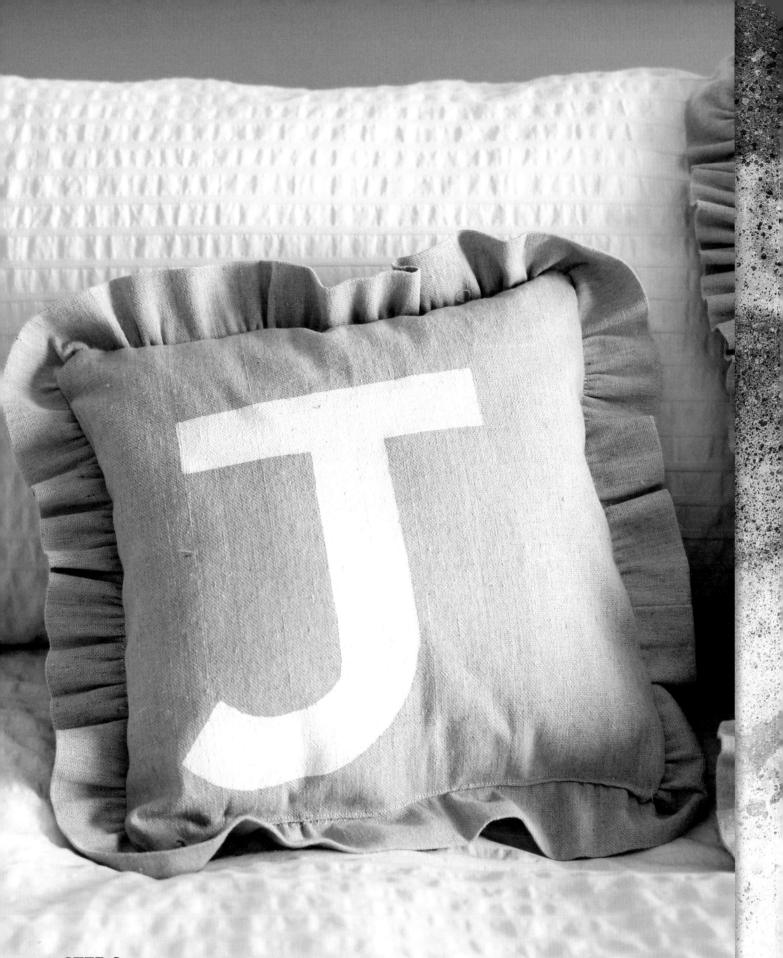

STEP 8

Pull the pillowcase right side out through that 6" gap. Stuff it with a pillow form or batting, and stitch up the gap. Painted pillow accomplished!

Log Stamp ARTWORK

PURCHASING ARTWORK for your home can be expensive and a bit overwhelming. Luckily, there are fresh and innovative ways you can add homemade artwork to your wall décor while staying within a budget. This log stamp artwork is interesting, simple to make, and easily customizable to your home colors! I love this project because it looks so lovely and professional; you could easily buy something similar from a high-end home décor store. But you made it yourself!

MATERIALS
- Quality paper (such as card stock or art-grade paper)
- Acrylic craft paints
- Foam craft brushes
- Log slices or log cross sections*
- Picture frame

*I cut some scrap wood using a miter saw and then sanded the surfaces smooth.

STEP 1
Choose a log slice for your first stamp. I enjoy using a variety of log slice shapes and sizes because it adds interest to the artwork. Using a foam brush, cover the face of the log slice in a coat of paint. The more paint you apply, the more brilliant and bold the stamp mark will be.

STEP 2
Next, while the paint is still wet, carefully stamp the log slice on the art paper. Once you place the painted surface on the paper, press firmly on the log slice to ensure a solid stamp impression.

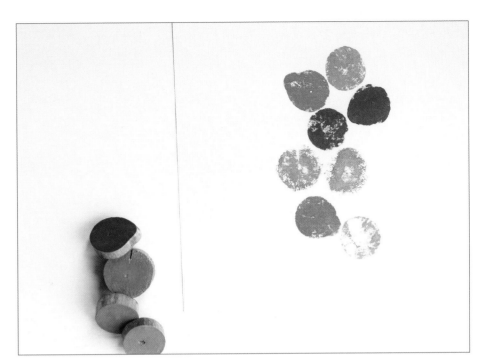

STEP 3

Repeat, stamping with the other log slices in various colors to create a dynamic artwork pattern. I like the stamp marks to have varying coverage, so I covered some logs in thicker layers of paint and some in thinner layers before stamping.

STEP 4

Allow the paint to dry completely, and then frame your log stamp artwork!

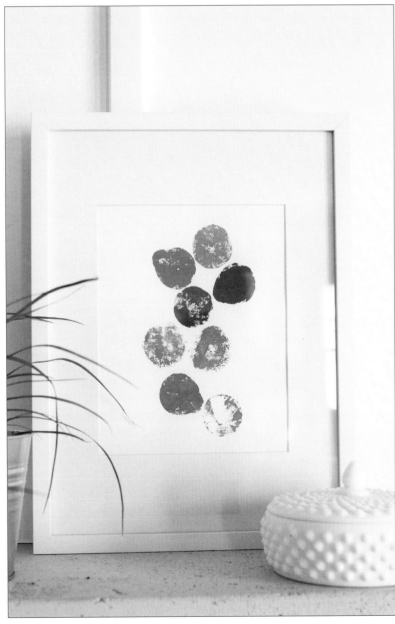

Log Stamp Artwork 109

Painted SILVERWARE

ONE OF MY FAVORITE THINGS to do is entertain guests. Adding unique and interesting details to a dinner party is a fun way to engage guests and make the event really special. A handmade paint project can easily transform secondhand silverware into festive table décor and a great conversation starter!

MATERIALS
- Assorted secondhand silverware*
- Painter's tape
- Acrylic craft paints or spray paint
- Paintbrushes

*You can use new silverware if you want to make a matching set.

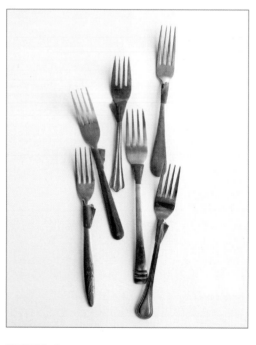

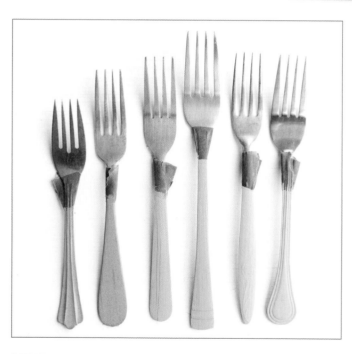

STEP 1

Use painter's tape to tape off the stem of the silverware. It's important to protect the pronged side of the fork that folks will be eating off of. The painter's tape will also create a clean paint line.

STEP 2

Next apply a smooth coat of bright paint to the stem of each piece of silverware. For best coverage, apply three coats of paint, allowing the paint to dry completely between coats.

STEP 3

After the paint is completely dry, carefully remove the painter's tape.

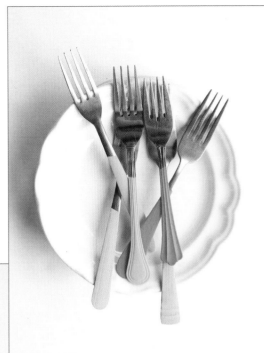

STEP 4

Now you're all set to enjoy some delectable cake (or other tasty treat) with friends and festive silverware!

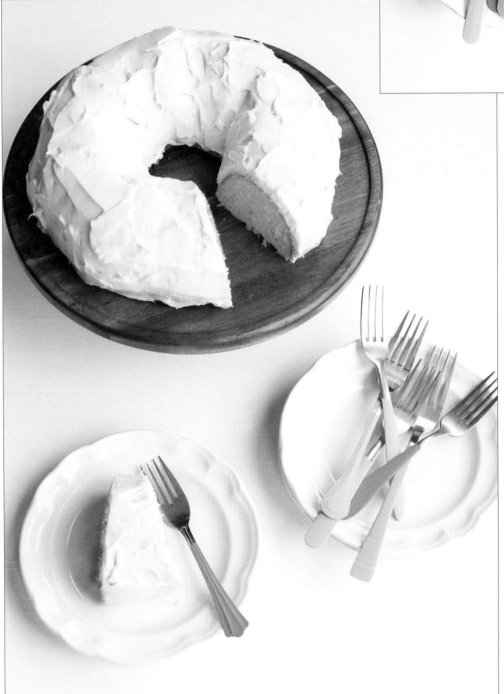

Calligraphy PLANTERS

INCORPORATING CALLIGRAPHY AND TYPOGRAPHY into everyday home décor creates visual interest that makes a house a home. These simple wooden planters are transformed into something unique and special with the use of paint markers and a little calligraphy practice. They are so simple to make and easy to love!

MATERIALS
- Paint markers in colors of your choice
- Pots or planter boxes*

*Paint markers can write on terra-cotta, glass, plastic, or wood.

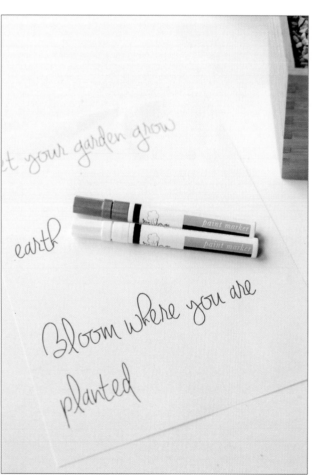

STEP 2

To use paint pens you must coax the paint to the tip of the pen by pushing the tip down on the surface of scrap paper several times. Once the paint has filled up the tip, practice writing some words on scrap paper until you are comfortable with the feel of the pen.

STEP 1

To begin, search for fonts (or calligraphy) and words that fit the look you desire. I found a loose cursive font I liked and printed out some phrases and words.

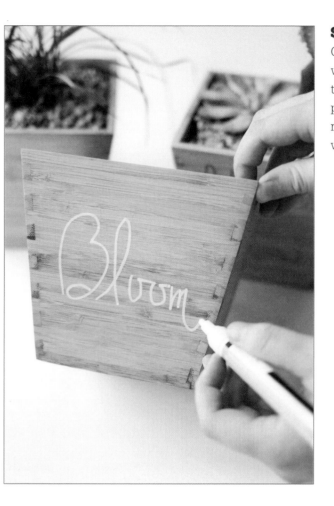

Carefully write the word or phrase on the planter with the paint pen. Be careful not to smear the word as you write.

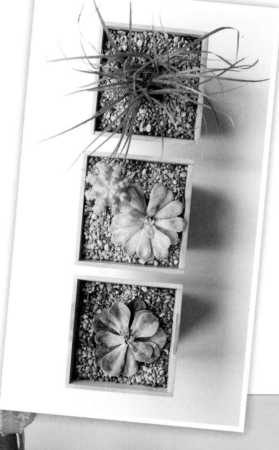

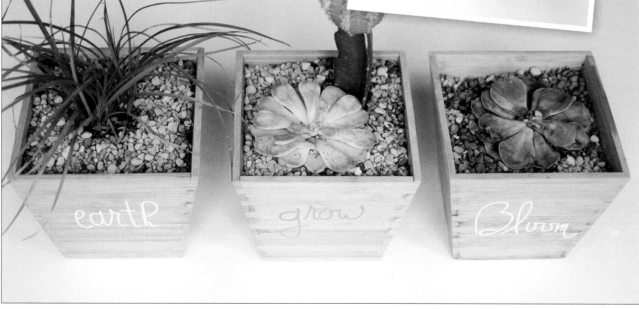

STEP 4

Once the paint dries, your planters are complete and ready to liven up any living space or patio!

Toy BLOCKS

PAINTING WITH KIDDOS can be a fun and messy experience! This wooden block craft is a great project to partner up with kids to create, because it is fun to paint and stain the blocks—and play with them later!

MATERIALS
- Wooden blocks in the size(s) of your choice (mine are 2" x 2" x 2")
- Acrylic craft paint in bright colors
- Wood stain
- Sponge craft brushes
- Clear sealing spray

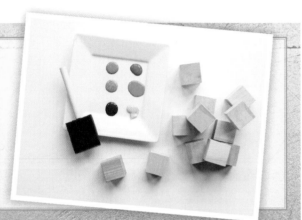

> → *Try using blocks* ←
> of various sizes to add some fun to the mix!

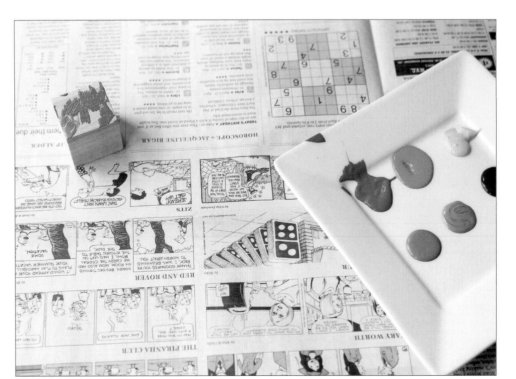

STEP 1
Begin by painting some of the blocks with acrylic paints. I prefer to paint the blocks in a solid color, but toddlers may prefer a more mixed and messy approach! One to two coats of acrylic paint should provide full coverage. Allow the paint to completely dry between coats.

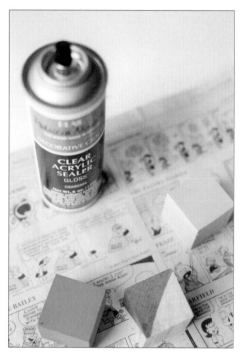

STEP 3

After the paint and stain are completely dry, spray all the block surfaces with clear sealing spray to protect the blocks and prevent paint chips.

STEP 2

Use a different sponge brush to apply stain to the surface of the other blocks. The more coats you add, the darker the stain will appear on the block.

Stains are often oil-based,

which means the brush can't be washed out with water.
You can simply discard the brush after your project.

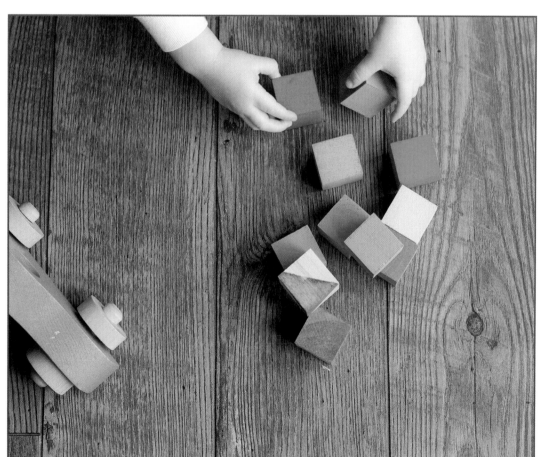

STEP 4

Once the seal dries, the blocks are complete and ready for play!

Watercolor CARDS

PERSONAL HANDMADE CARDS are a great way to spice up a gift or show your appreciation. These customized watercolor greeting cards look great as gift toppers, or they can be the perfect way to say, "hello," "thanks," or "happy birthday!" With a little creativity and a set of watercolor paints you can make personal cards for any occasion!

MATERIALS
- White watercolor paper
- White card stock, cut to 5" x 10"
- Watercolor paints
- Paintbrush
- Craft knife
- Glue stick

STEP 1
To begin, select a word for the front of the card. I chose "hello." Use a craft knife to cut out the word on the card stock. Keep in mind that the card will be folded in half, so you want to cut out the word on the appropriate side and going the appropriate direction.

STEP 2

Work slowly and carefully to cut out each letter. Then fold the card stock in half to make the card.

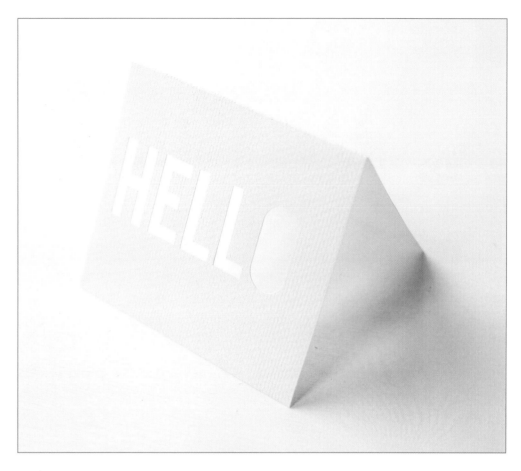

STEP 3

Next grab the watercolors and paintbrush. Begin to paint stripes of watercolor in varying colors on the watercolor paper.

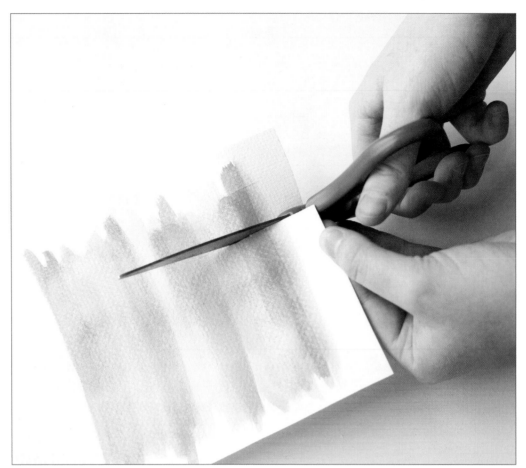

Allow the watercolor paint to dry completely. Then cut a rectangle out of the watercolor paper to fit behind the word on the front of the card.

STEP 5

Unfold the card, and glue the striped watercolor paper to the inside of the card so that the color is visible through the cutout word from the front of the card.

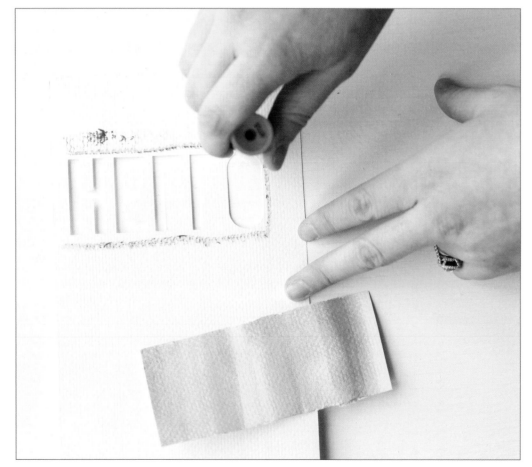

STEP 6

Allow the glue to dry. Then fold the card in half, and your festive card is ready to bring a smile to someone's face!

Faux MERCURY GLASS

FRESH FLOWERS LIVEN UP any and every living space. They are my favorite finishing touch in a room and a focal piece for parties! But every lovely bunch of flowers needs a pretty container. No need to purchase an expensive vase though—this up-cycled faux mercury glass vase will do the trick! Here is how you can make one of your own.

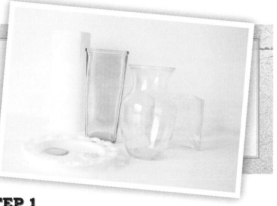

MATERIALS

- Secondhand vase(s)
- Gold and silver acrylic craft paint
- Paper towels or napkins

STEP 1

Begin by ripping off a single paper towel. Lightly bunch up the paper towel in your hand to form a scrunched ball.

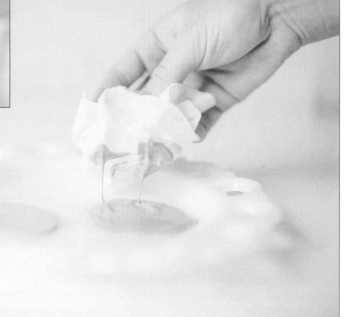

STEP 2

Next dab the towel in gold paint.

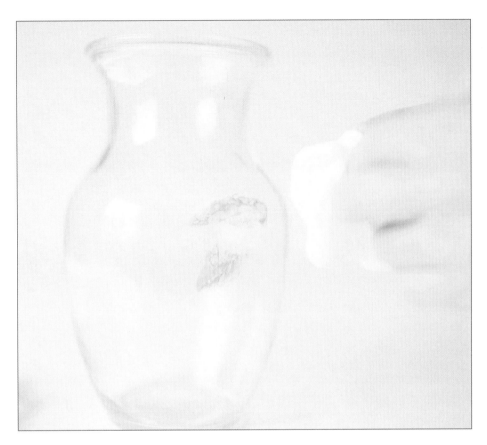

STEP 3

Dab the paint onto the surface of the vase; don't rub!

STEP 4

Continue to dab the surface of the vase. The first few dabs will be heavier in paint, so I suggest you dab back over those areas to thin the paint out.

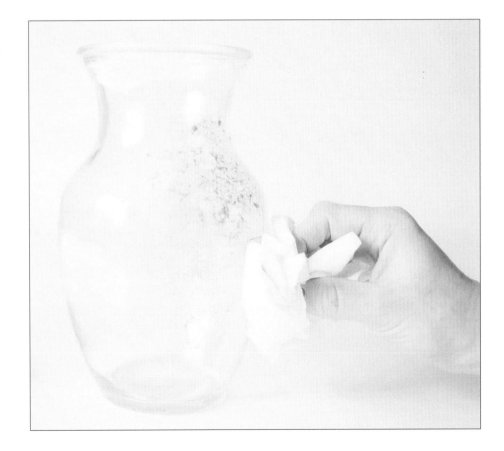

STEP 5

Dab over the entire surface of the vase. Then let the gold paint dry completely.

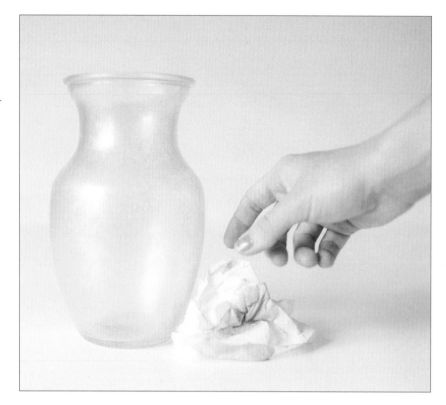

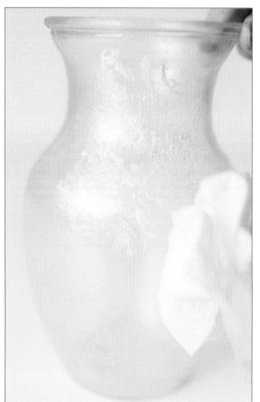

STEP 6

Scrunch a new paper towel and repeat steps 2 through 5, this time with silver paint. The layer of silver paint should be transparent enough that you can see some of the gold paint underneath.

If you prefer a more

gold mercury glass look, simply apply the silver paint first and the gold paint second.

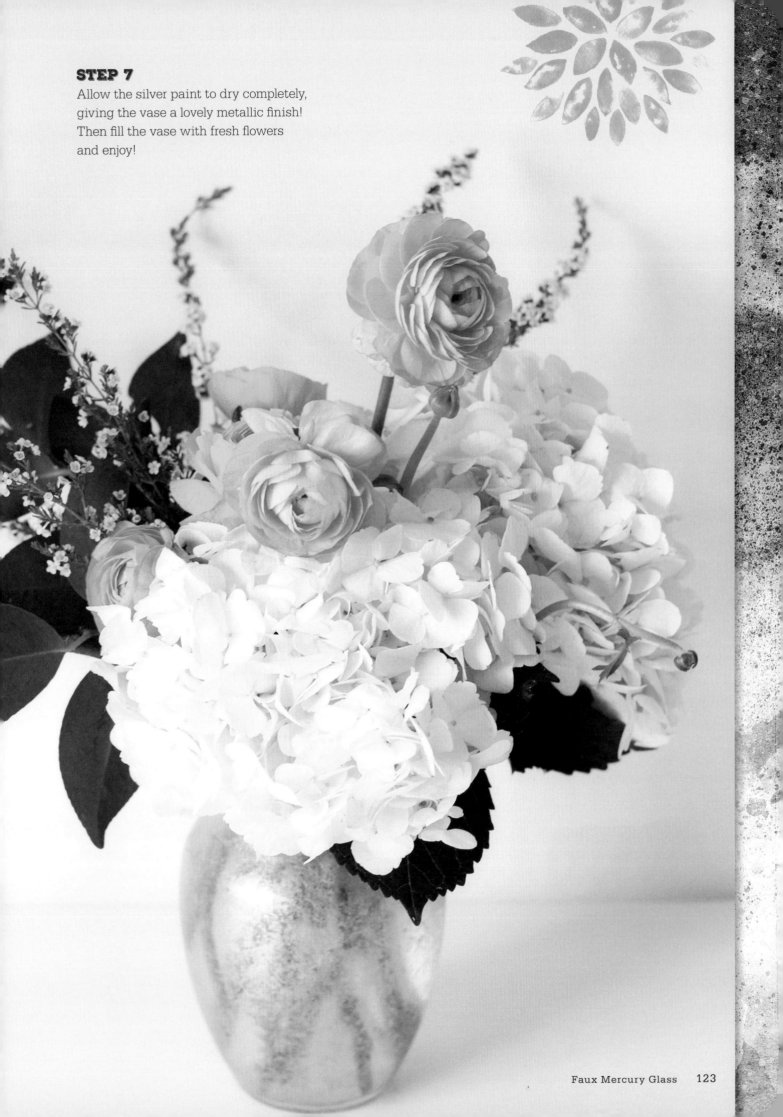

STEP 7

Allow the silver paint to dry completely,
giving the vase a lovely metallic finish!
Then fill the vase with fresh flowers
and enjoy!

Painted Cutting BOARD

CUTTING BOARDS ARE ONE of those fun kitchen items that can serve a dual aesthetic and functional purpose. After the vegetables are chopped, a cutting board can be propped up on a counter as a beautiful kitchen accessory. Dressing up your cutting board is even more fun! Here I'll teach you how to add food-safe paint to the surface of a cutting board, creating a vibrant pattern.

MATERIALS
- Wooden cutting board
- Food-safe paint or enamel paint*
- Painter's tape
- Sponge painting brush

*The paint used in this project is dishwasher-safe and safe to eat off of or prepare food on.

STEP 1
Begin by using the painter's tape to create a pattern on the cutting board. I decided to create a simple series of triangles, but you can experiment and create something unique of your own!

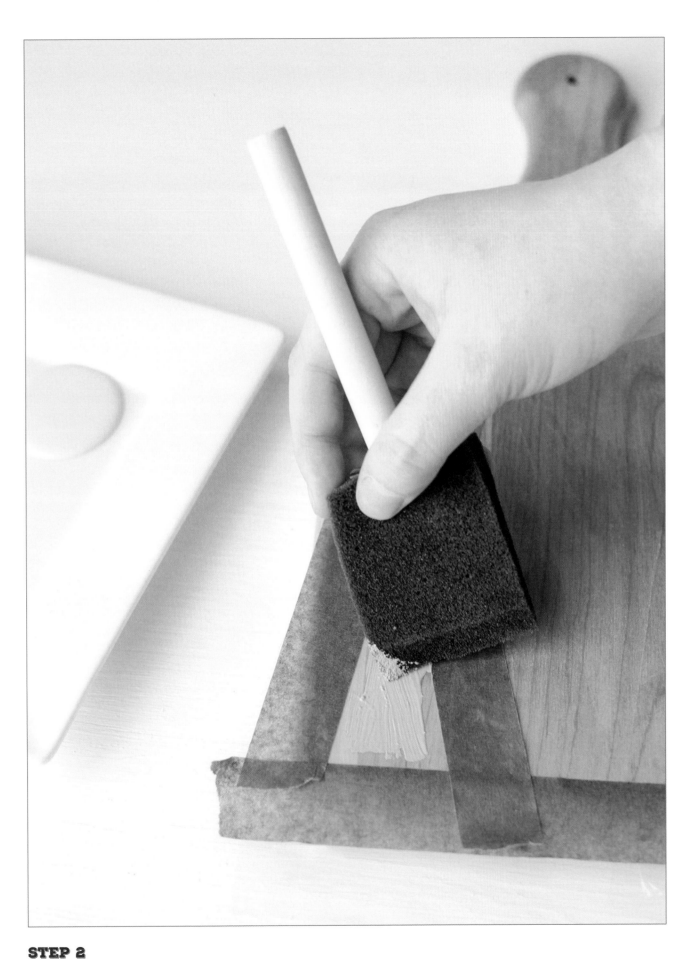

STEP 2

Using the sponge painting brush, apply paint to the surface of the cutting board inside the taped-off pattern. You can select a variety of paint colors for a livelier pattern or one color for a simple pattern.

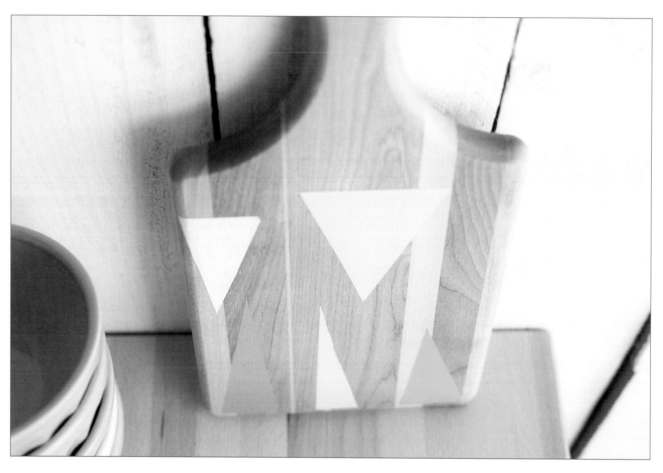

STEP 3

Allow the paint to dry completely, and then carefully remove all of the painter's tape. Pull the tape up slowly at an angle so as not to damage the fresh paint.

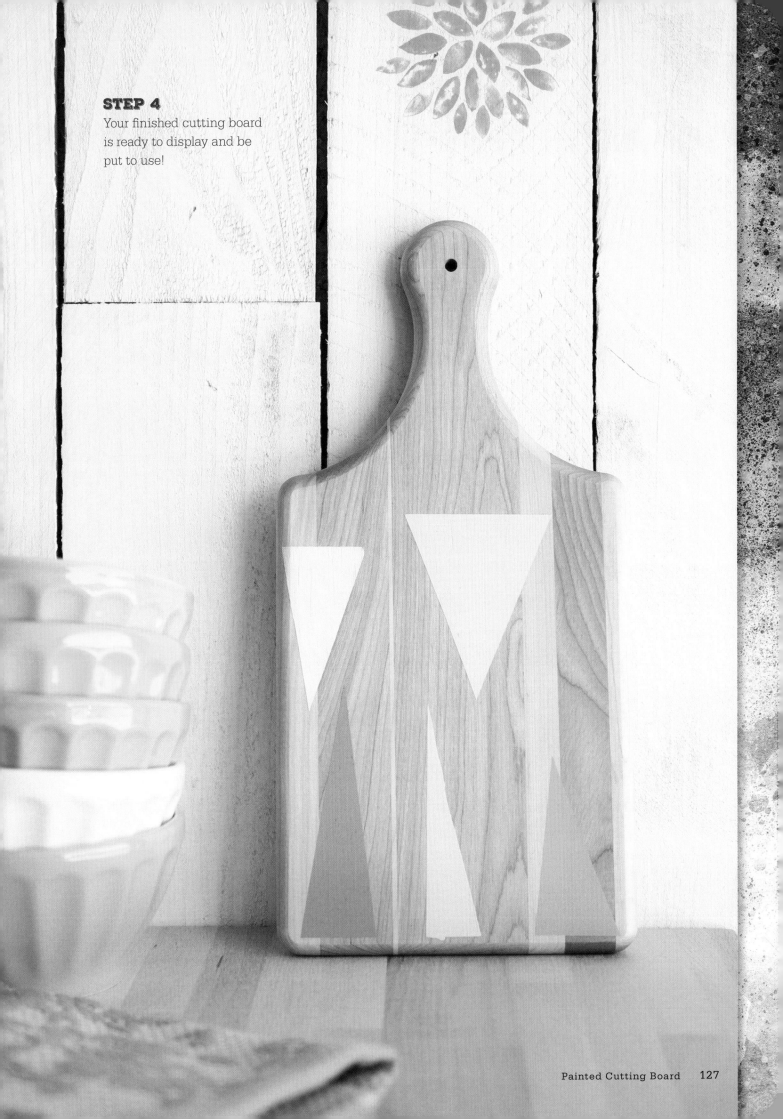

STEP 4
Your finished cutting board is ready to display and be put to use!

Wood
INITIAL SIGN

ADDING ARTWORK TO WALLS makes a house a home. Creating a personal and beautiful piece of artwork is simple and easy! This industrial wooden letter sign can be easily customized with a meaningful family initial and makes a beautiful focal point in your home!

MATERIALS

- 5 rough boards, 4" wide x 36" long
- 2 pieces of trim, 16" long
- 10 screws
- Drill with a pilot hole bit (smaller in diameter than the screws) and a Phillips head bit
- Wall paint or craft paint
- Painter's tape
- Paintbrush

STEP 1
Begin by laying all five rough-cut boards side by side.

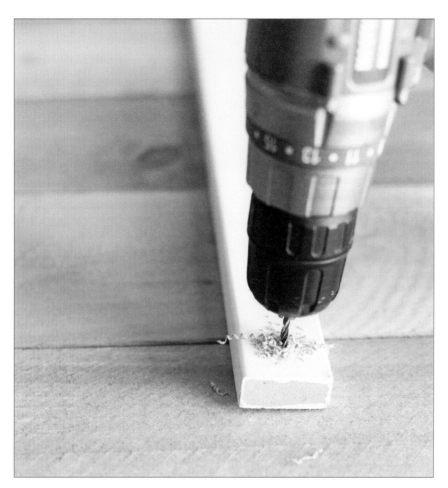

STEP 2

Then place the two 16" trim pieces perpendicular to the rough-cut boards, spacing one approximately 6" below the tops of the boards and the other 6" above the bottoms of the boards. Use the pilot hole bit to drill a pilot hole through the trim pieces over each of the five boards (10 holes total).

STEP 3

Next drill screws into the four pilot holes at the ends of the trim pieces. Screwing in the four end screws first will help the boards stay together tight while you screw in the rest.

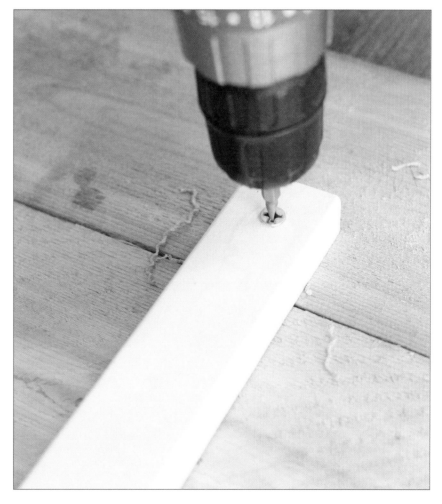

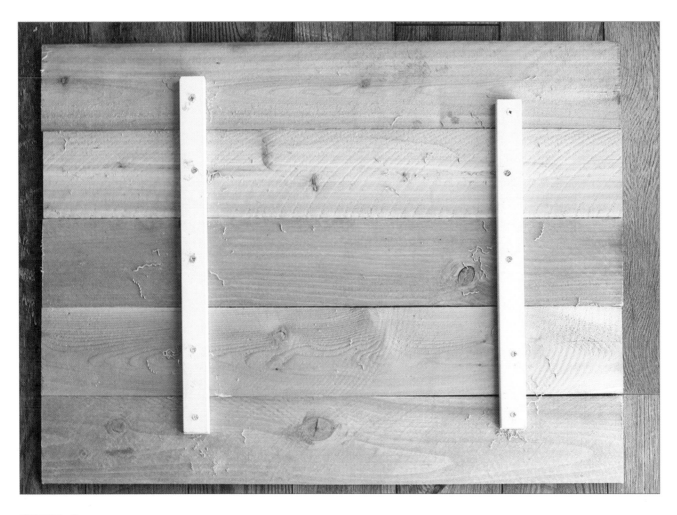

STEP 4

Now add a screw to all the other pilot holes, attaching each board to the trim pieces. Your wooden canvas is complete!

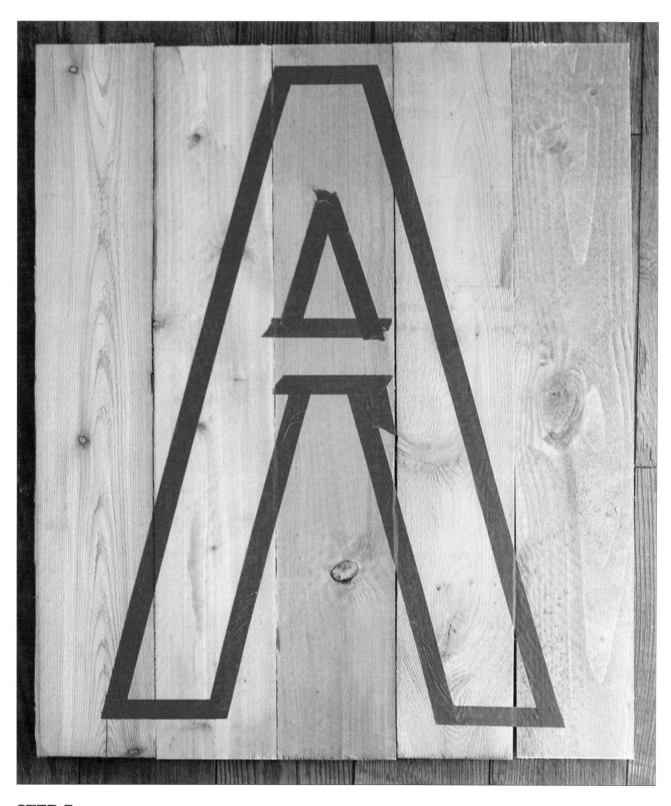

STEP 5

Time to create the letter design. Flip the wood canvas over. Using painter's tape, outline the letter of your choice on the boards.

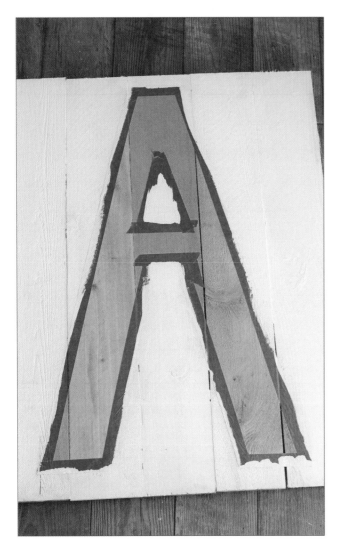

STEP 6

Paint any part of the surface you like. For this "A" sign I wanted the "A" to be natural wood and all the negative space to be white. You could do the opposite for an equally interesting effect!

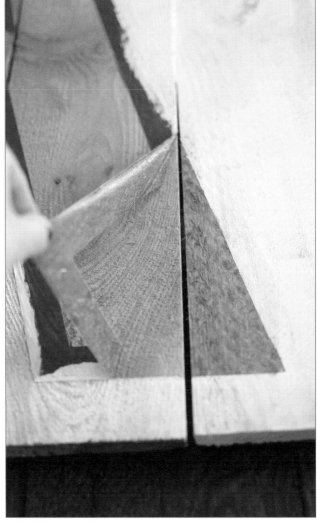

STEP 7

Allow the paint to dry completely before removing all the painter's tape.

Want to add a splash of color?

After removing the painter's tape, apply new lines of tape on the outside edges of the letter to protect the paint. Then paint the inside of the letter with the color of your choice!

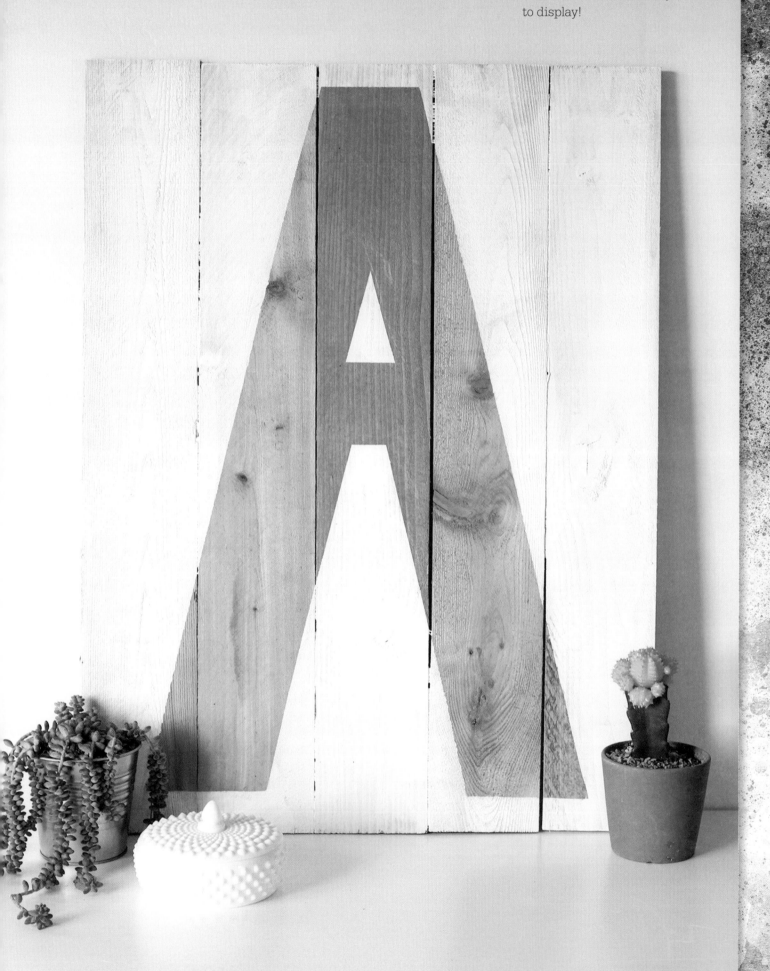

Watercolor PLACE CARDS

I LOVE ENTERTAINING FAMILY AND FRIENDS IN MY HOME—or anywhere! Spending time together is the perfect excuse to prepare delicious food, decorate my table, and stay up late chatting and laughing. Adding some personal details to the party is my favorite way to make an ordinary night extraordinary! And these personalized watercolor place cards do just the trick!

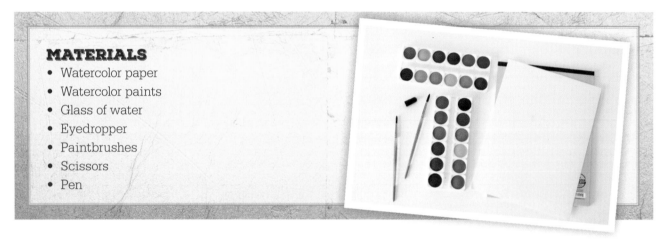

MATERIALS
- Watercolor paper
- Watercolor paints
- Glass of water
- Eyedropper
- Paintbrushes
- Scissors
- Pen

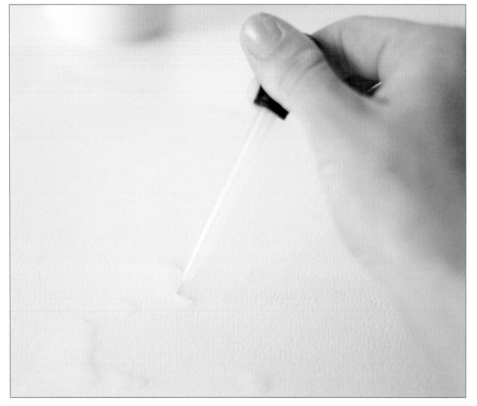

STEP 1
To begin, use the eyedropper to drop water splotches onto the paper surface. Get creative with the size and dispersion of the drops!

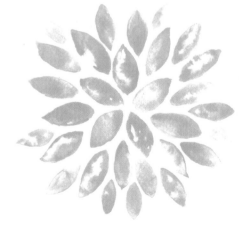

STEP 2

Use the same dropper to add water to the surface of the watercolor paint you want to use. The water will help soften the paint. Next absorb the softened paint onto a paintbrush.

STEP 3

Then simply touch the paintbrush to the water spots on the paper. This is where the real magic happens. Once you touch the color to the water splotch, the pigment will fill the area of water.

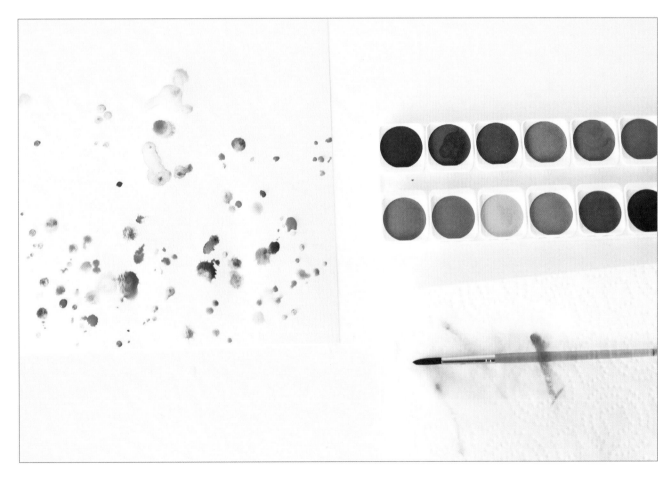

STEP 4

Repeat this process with various colors. You can even add multiple colors to a single water splotch! There's no way to make a mistake here.

STEP 5

Allow the paint to dry for several hours, creating a beautiful pattern of colors. Then cut the paper into smaller rectangles, about 3" x 5", perfect for place cards.

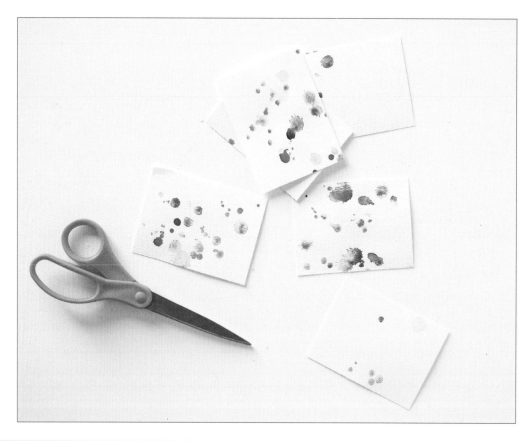

STEP 6

Add a guest name to each card.

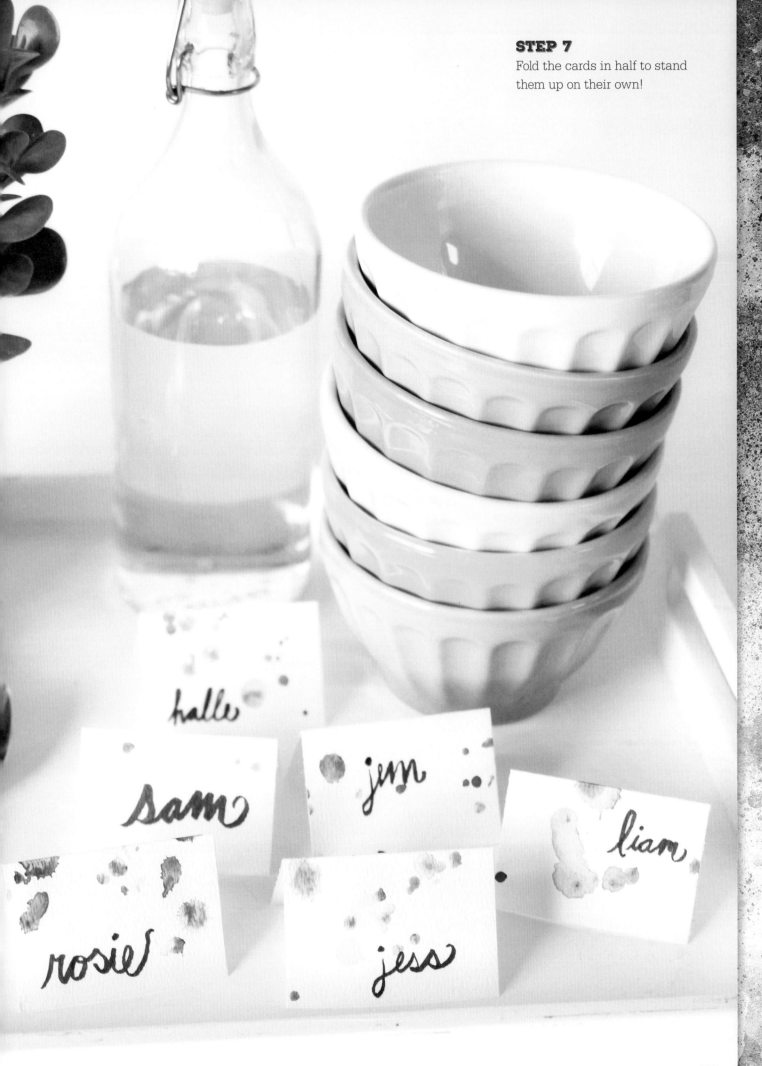

STEP 7
Fold the cards in half to stand them up on their own!

Painted Burlap
PLACE MATS

PLACE MATS AT TABLE SETTINGS are a perfect dining accessory—and a great way to protect your table from drips and spills! They also add dimension to each place and can be the perfect way to customize a special dinner or party. These painted burlap place mats are a fun and easy way to add layers to your dining experience without spending lots of money!

MATERIALS
- Burlap fabric
- Acrylic craft paint
- Painter's tape
- Scissors
- Sponge paintbrush

STEP 1
First cut the burlap into place mat-sized rectangles. Mine are 18" x 12".

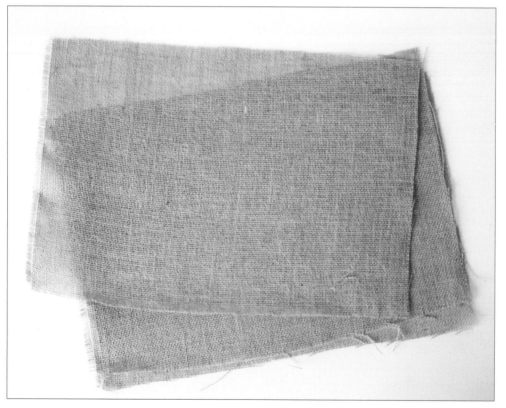

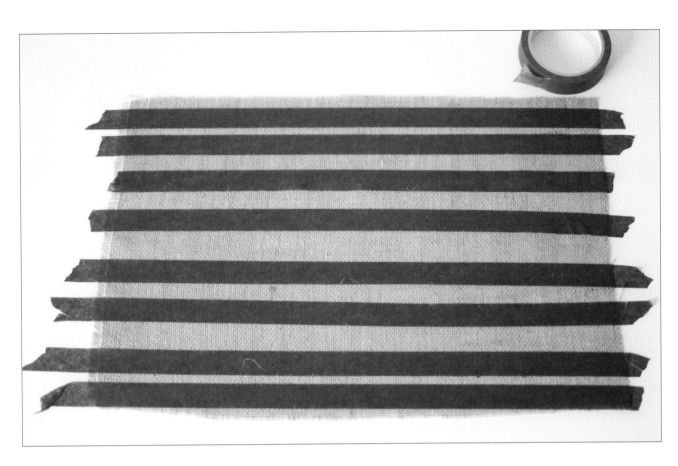

STEP 2

Next lay a place mat flat on a solid surface. Use painter's tape to tape off the areas of the burlap where you do not want paint. I made a striped pattern because it is easy to create and looks great under dishes.

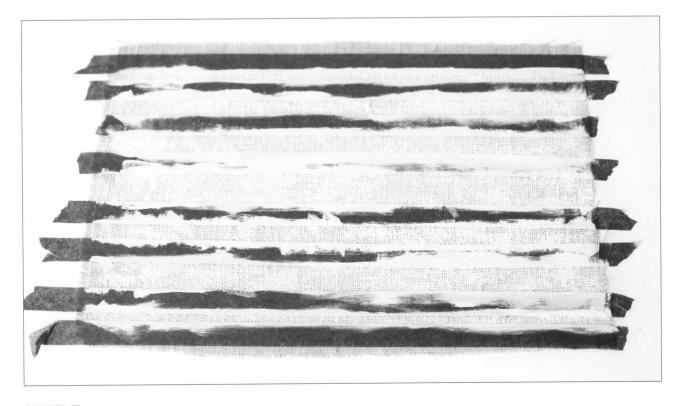

STEP 3

Use the sponge paintbrush to paint all the areas of the place mat that are not covered with tape. Allow the paint to soak into the burlap and dry for a few hours.

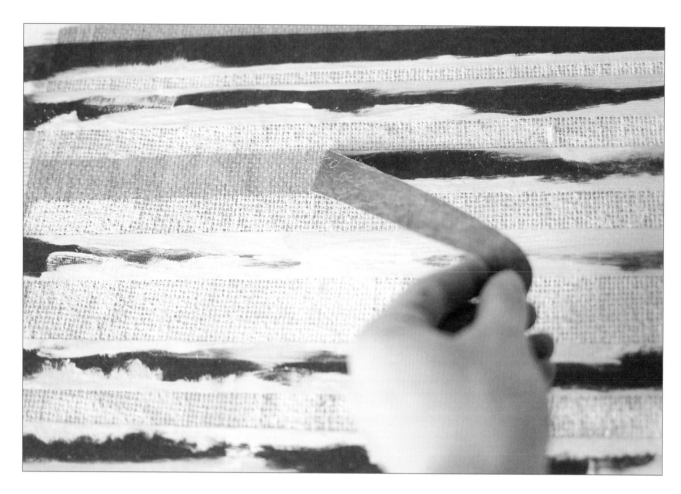

STEP 4

When the paint is totally dry, remove all the painter's tape, pulling it off at an angle.

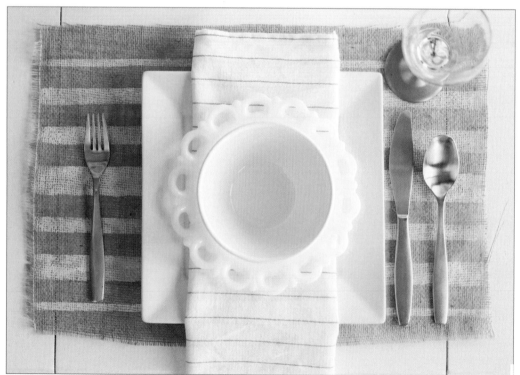

STEP 5

Once all the tape is removed, your fun painted pattern is revealed. Set the table, and have a special dinner party!

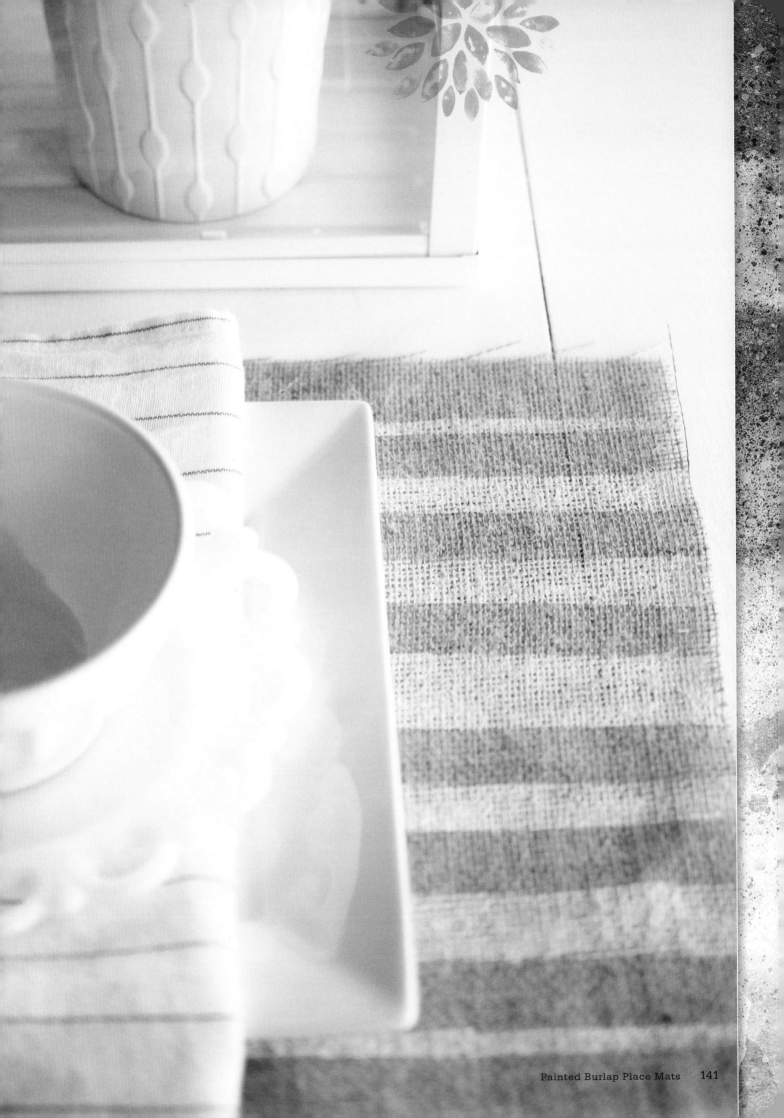

Refreshed PAINTED CHAIR

PAINTING FURNITURE CAN BE INTIMIDATING, especially if you have never tried it before! This painted chair DIY is the perfect project for beginners when it comes to painting furniture. It's also a great way to revitalize outdated or old furniture that needs a second life!

MATERIALS
- Wooden chair
- Water-based paint
- Quality paintbrush
- Painting tarp
- Sandpaper

STEP 1

Lay out the tarp on the floor, and set the chair in the center. In order for the paint to absorb onto the chair, it helps to rough up the surfaces with sandpaper first. After sanding, wipe off all the dust with a washcloth.

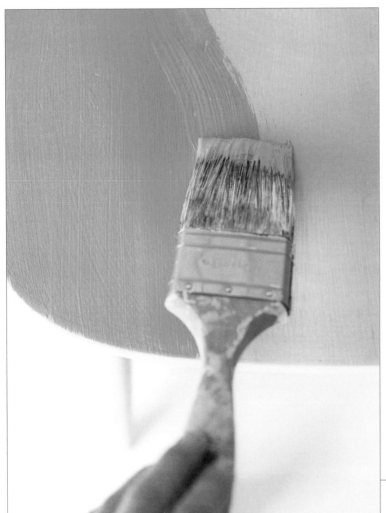

Now for the fun part—paint! Begin to apply paint to the chair in thick coats.

STEP 3

Continue to apply coats of paint until the previous paint color or wood is no longer visible. Make sure that you allow plenty of time for each coat to dry. For this particular chair, I had to use three coats of yellow paint.

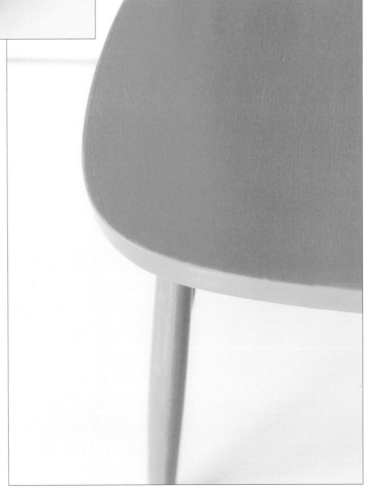

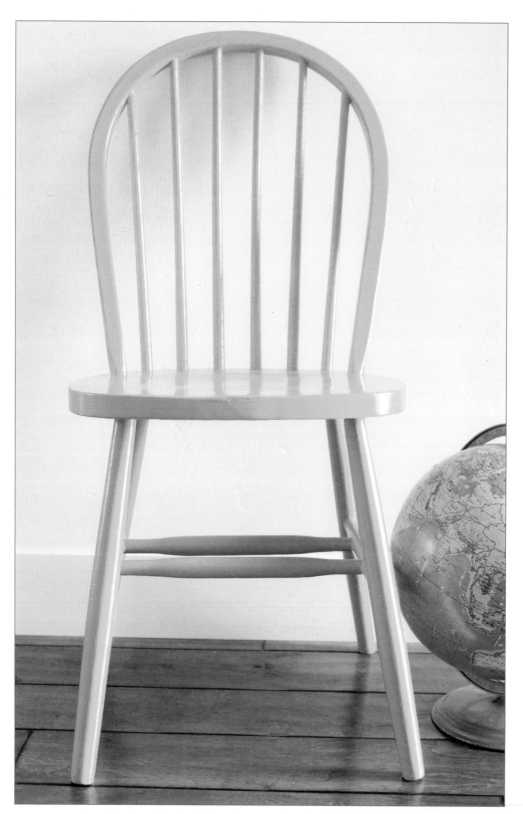

STEP 4
Allow the final layer of paint to dry completely before using or sitting on the chair.

You can easily repaint furniture that has an existing wax- or oil-based paint on it by first adding a coat of oil-based primer to all surfaces of the piece. The primer will enable you to paint the furniture with water-based paint in any color of your choice.